IMAGES
of America

MILLER PLACE

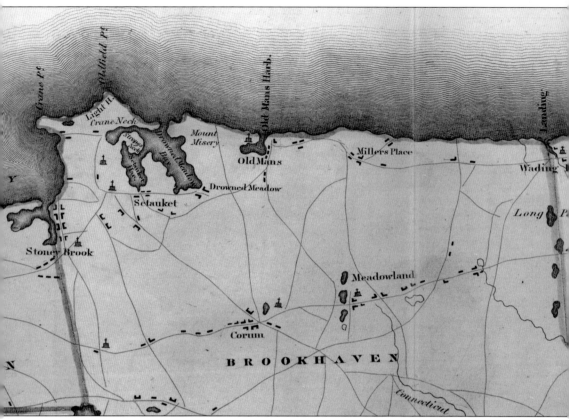

Miller Place is located on the north shore of Long Island in Brookhaven Town, Suffolk County, New York. Part of the Old Mans territory purchased from the Setalcott in 1664, Miller Place derives its name from the first permanent settler, Andrew Miller. Modern-day Miller Place is bordered by Mount Sinai to the west and Rocky Point to the east. (Courtesy of Special Collections, Stony Brook University Libraries.)

ON THE COVER: Mail arrived twice daily to the post office from the railroad station. Telephones were rare, and writing was the common mode of communication between communities. Postcards became the method of choice for sending greetings to friends and relatives around the country. Here girls from the Holiday House have just dropped off mail to go in the next post or are waiting for the mail to be delivered. (Courtesy of Warne Randall.)

IMAGES
of America

MILLER PLACE

Dear Anna,
To History!
Mindy Kron

Edna Davis Giffen, Mindy Kronenberg,
and Candace Lindemann

Edna Davis Giffen

ARCADIA
PUBLISHING

Published by Arcadia Publishing
Charleston SC, Chicago IL, Portsmouth NH, San Francisco CA

Printed in the United States of America

Library of Congress Control Number: 2009941375

For all general information contact Arcadia Publishing at:
Telephone 843-853-2070
Fax 843-853-0044
E-mail sales@arcadiapublishing.com
For customer service and orders:
Toll-Free 1-888-313-2665

Visit us on the Internet at www.arcadiapublishing.com

*Dedicated to the members, past and present, of the
Miller Place–Mount Sinai Historical Society*

CONTENTS

ACKNOWLEDGMENTS

We would like to thank the following people who contributed photographs and/or information from their private collections: Harry Randall, Warne Randall, Helen Hocker Samuels, Jane Davis Carter, Margaret Davis Gass, Rupert H. Hopkins, Frances Korinek Iwanicki, Carol Gumbrecht, Jacqueline Smith Flourney, Helene Steffens Walker, Martin Steffens, Evelyn Cramer, Willis H. White, Elaine Hoffman, Janene Gentile NSYC, Kathy Rousseau and Antoinette Carbone of the Miller Place Civic Association, and Kristen J. Nyitray the head of Special Collections and University Archives at Stony Brook University Libraries. Their photographs added to those from the collection of the Historical Society. Thanks to Warne Randall and Robert Finton for preparing the discs required for early submission. Thank you to Marc Lindemann for proofreading the work. A very special thank you to Ken Brady for his time and effort in scanning over 200 items that were being considered for the publication. Unless otherwise noted, all photographs are courtesy of the Miller Place–Mount Sinai Historical Society.

INTRODUCTION

Miller Place is a close-knit community that takes great pride in its heritage. Brookhaven Town purchased Old Mans from the native Setalcott in 1664. Andrew Miller is considered the first permanent settler in this area. By the early 1700s, the agricultural settlement east of Pipe Stave Hollow Road and Mount Sinai Harbor was known as Miller's Place. In the early years, roads did not have official names. Travelers spoke of taking the main thoroughfare that led from "town," Setauket, to "Andrew Miller's Place." The area became known as "Miller's Place," and eventually "Miller Place" in the late 19th century.

A strong current of continuity connects Miller Place to its founding families. The oldest extant house, the 1720 William Miller House, was owned and occupied by his descendants well into the 20th century. An interesting example of how colonial families accommodated their growing households is that the home is actually comprised of three separate houses. The Millers purchased two empty houses and then rolled them to either side of the central house. The Miller Place–Mount Sinai Historical Society now maintains the house as a showcase of colonial life.

Divided loyalties in the Revolutionary War pitted family members against one another. Most local residents joined the Patriot cause but some were British loyalists. Local militia attacked Tories and British troops terrorized Patriot families in midnight raids. Under the cover of darkness, Connecticut Patriots attacked a Miller residence, mutilating one man and shooting 15-year-old William Miller dead as he peered from a window.

For most of its history, however, Miller Place was a peaceful, rural community. Settlers built houses along present-day North Country Road with vast tracts of farm land stretching north to Long Island Sound and south as far as present-day State Route 25A. Farmers planted grains and flax in the 1600s and 1700s, vegetable and fruit crops in the 1800s, and root vegetables in the 1800s and 1900s. Miller Place remained an agricultural community well into the late 1900s. The last of the truck farms to ship produce closed in the 1990s, replaced by nursery and sod farms south of State Route 25A. The Carter Christmas Tree Farm is the only local farm remaining north of State Route 25A.

Religion played an important role in building community spirit. In the 1740s, during the First Great Awakening, settlers called upon a circuit-riding Presbyterian minister to preach the gospel. In 1789, the local hamlets organized the Congregational Church on the modern-day border of Mount Sinai and Miller Place. Congregants purchased a house for the minister next to the Academy, which remains the home of the minister to this day.

As the nation industrialized, this coastal community flourished. In addition to farming, the cordwood industry provided income for the hamlet. Men cut cordwood and brought it along landing roads to the beach. Many residents served as ships' captains during the 1800s.

With growth came commerce. Although most retail stores were in larger villages such as Port Jefferson, Patchogue, and Bridgeport, Connecticut, there were small general stores in Miller Place selling groceries, dry goods, clothing, sundries, and domestic goods as early as the 1790s.

For most of the 1800s, Miller Place students learned reading, writing, and arithmetic in a one-room schoolhouse. Initially families of the schoolchildren contributed funds for the teacher's salary and lodging. Each family also provided supplies and necessary materials, such as wood for the stove.

As part of an ongoing commitment to education, residents raised money through subscription to open the Miller's Place Academy in 1834. Students from across Long Island enrolled in the preparatory classes offered by this "quiet, industrious, and moral" community. With an increase

in funding for public education following the Civil War, private academies lost their appeal. The Academy closed for use as a private school in 1868 but continued to serve the community as a library, meeting hall, and a public primary school. Still owned by the descendants of the founding subscribers, the Academy operates as a library for local residents.

Students requiring secondary education during the late 19th century and most of the 20th century had to matriculate at Huntington High School and then after 1894, Port Jefferson High School. Today all grades of education are contained within the district.

During the Civil War, Miller's Place was not large enough to form its own brigade; however, many of the community's prominent men, including those from the founding Miller family, joined units from all over Long Island and the rest of New York.

A reformist spirit gripped the nation in the postwar period and Miller Place was no exception. In addition to an active Women's Christian Temperance Union (WCTU) chapter, Miller Place residents formed numerous religious, civic, and intellectual clubs, including the Forum and the Christian Endeavor.

When the first train came steaming into the Miller Place station in 1894, it brought change. The Long Island Rail Road (LIRR) had extended its line to Wading River, and the area became more accessible to vacationers from New York City.

Around 1900, first Grace Church Camp and later Camp Nonowantuc provided fresh air and healthy exercise for young boys.

The Holiday House, a summer retreat for young women from New York City, opened in the 1890s. The Association of Working Girls' Societies converted the former private home to a dormitory-style building and later added the Harbor House to accommodate greater numbers. Vacationers enjoyed bathing, horseback riding, bicycle riding, and games. Weekly dances were open to guests, including local residents.

The railroad station building burned in 1903 and again in 1934. Ridership of the railroads decreased with the advent of automobile travel, and by 1938, the LIRR ended its line at Port Jefferson and decommissioned the tracks to Wading River. Following World War II, the Holiday House could not compete with more exotic vacation spots. After years of vandalism and neglect, the building was bulldozed in 1970.

Miller Place's seaside setting retained its charm for vacationers through the 20th century. City dwellers built holiday cottages or purchased summer homes in one of the new bungalow communities. Houses ranging in size from bungalows to large, late-Victorian houses sprung up along beachfront property.

The Miller Place Inn, constructed from the horse and cow barns of Joseph Rowland, became a neighborhood fixture. This restaurant and inn prepared game brought in by the guests after a day of hunting. Initially offering facilities for civic and private gatherings, the inn is now a catering hall.

The population expanded into the suburbs following World War II, and Miller Place became a commuter community. Many of the vacation cottages now serve as updated family homes. Construction increased in the 1970s and 1980s to accommodate a burgeoning population. New businesses have flourished along the main highway and in the historic buildings along North Country Road.

Like earlier settlers, Miller Place residents share a sense of civic pride. In 1976, the Miller Place Historical Society organized local community groups for a celebration of the bicentennial. Through the efforts of the Historical Society, the area along North Country Road became the first historic district in the Town of Brookhaven and is listed on the National Register of Historic Places. In 1979, the Historical Society acquired the building and property of the William Miller House, which showcases the area's history through tours and year-round events.

The first four chapters of this book highlight photographs dating from the late 1800s to the 1970s. The last chapter includes scenes of contemporary Miller Place, a community that continues to cherish its historical heritage.

One

ANDREW MILLER'S PLACE
1720–1880

Many of Miller Place's remarkable historic homes remained occupied by descendants of the founding families well into the 20th century. D. Spencer and Elizabeth Quinn Millard stand in the front doorway of their home around 1940, originally the William Miller House. Built in 1720, it is the earliest extant house in Miller Place. Note the Dutch door, shown with the top half open—an unusual feature in English-settled Suffolk County. (Courtesy of Margaret Davis Gass.)

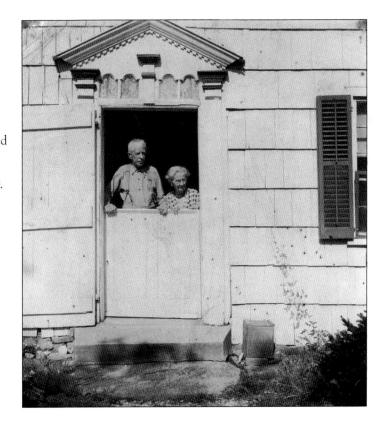

OLD MILLER PLACE, Miller Place, N. Y.

Two empty houses were purchased from elsewhere in the village, rolled to 75 North Country Road, and added as wings to the original William Miller House. The west end was added in 1750 and the east in 1815. Consistent shingle siding gives the facade a unified appearance, but the rear of the house with its clapboard and two different types of shingles testifies to this piecemeal construction method. In 1758, Capt. Thomas Terry commandeered the house, while he mustered the militia for duty in the French and Indian War. The sole interior plumbing in this relatively unaltered house consists of a pump in the kitchen. Lacking central heat, Harry Millard, the last resident of the house, would retire to an elder care facility and then return home with the warmer weather. When Harry Millard passed in 1978, the Mount Sinai Historical Society purchased the William Miller House to preserve it from destruction. Today the society uses the house to showcase the community's heritage through tours and events.

One of the wealthiest men in town, Richard Miller built his house adjacent to the pond at 178 North Country Road. He held several government offices, including trustee, supervisor, and justice of the peace. His only son, Richard Miller III, was an avowed Tory. Men under the command of Capt. Daniel Roe, Miller's cousin, killed him in Selden. Although not visible in this photograph, the 18th century components of the house remain part of the structure. (Courtesy of Warne Randall.)

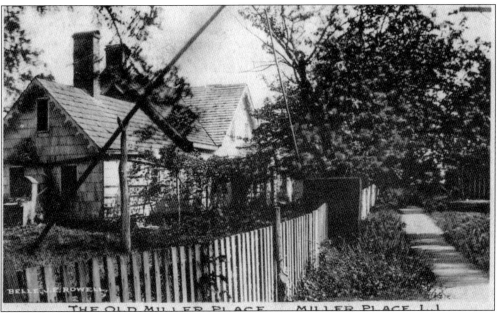

Ebenezer Miller fought on the side of the Patriots in the Revolutionary War Battle of Long Island. In August 1781, men from Connecticut launched a midnight raid on Miller's Place. One of the raiders shot William Miller, Ebenezer's 15-year-old son, when he peered out of the window of the house. During the Civil War, Frederick Miller, a descendant of Ebenezer Miller, joined the 1st Mounted Rifles and later settled in Nashville, Tennessee.

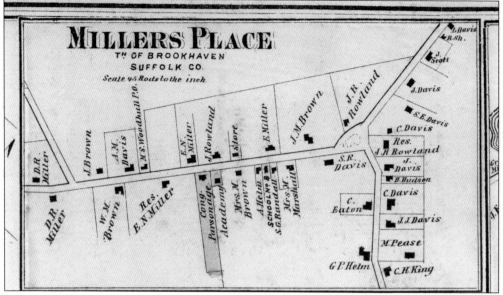

Located in the town of Brookhaven on the North Shore, Miller Place is remarkable for its concentration of extant historic properties along North Country Road. The name derives from the first permanent settler, Andrew Miller, who purchased a parcel of land in the Old Mans territory from John Thomas. During the early 1700s, the town became known as Miller's Place and in 1894, Miller Place. (Courtesy of Special Collections, Stony Brook University Libraries.)

Stone mile markers were placed every mile along North Country Road from Riverhead, the county seat. When Benjamin Franklin was appointed postmaster general by the king, he instituted the use of mile markers to standardize delivery and postage. Prior to this innovation, mail delivery could be unreliable and unpredictable, with packages and letters arriving at the nearest place of business.

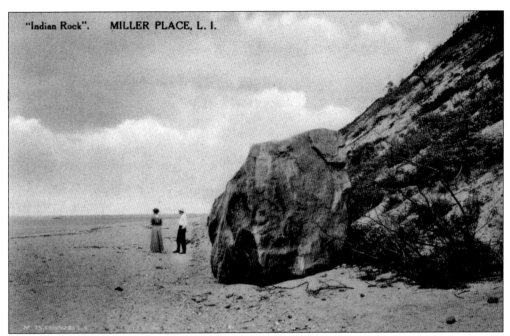

"Indian Rock". MILLER PLACE, L. I.

At the time of this photograph, Indian Rock abutted the cliff east of Miller Place Beach. So much of the cliff has eroded that it is now possible to walk between the rock and the cliff. In 1990, the town placed gabions, wire traps filled with rocks, along the bottom of the cliff to the west of Gully Landing Road. Residents have also made unsuccessful makeshift attempts at stabilizing the cliffs.

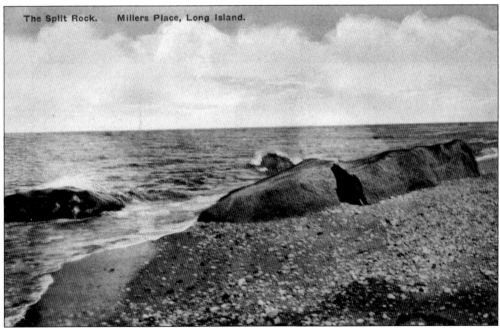

The Split Rock. Millers Place, Long Island.

Long Island is formed from two spines of glacial moraine. Like most North Shore beaches, Miller Place has rocky deposits left by the receding glaciers. Known as Split Rock, this formation is covered by water during high tide. It is a popular location for vacationers to take photographs.

The walk down to the beach from the house. It is lovely! with the choice of the sand, all billowy. Idge.

Cordwood was the most profitable product for local farmers. Cut during the winter, the wood was then brought to the beaches along one of four landing roads and stacked in cords on the beach, where it would remain until spring. Looking north down Gully Landing, currently Lower Rocky Point Road, the houses visible are those of Mrs. Hannah (King) Rowland (left) and Lewis Davis, the latter structure is no longer standing.

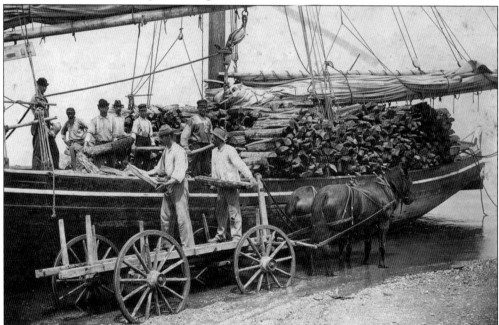

Beginning in spring, schooners would anchor at high tide. Once the tide went out, the boat became accessible for loading. The crews sailed with the cargo to New York City or the brick factories along the Hudson River. The men are, from left to right, James W. Davis, Charles Sells, Frank Satterly, Gus Tooker, Louis Satterly, and Capt. Daniel Davis. On the wagon are, from left to right, Forrest B. Randall and Lorenzo H. Davis.

Miller's Landing, leading downhill past the Millard Estate, is now known as Landing Road. This was another of the four landing roads that lead to the beach, along with Nathanial Davis Landing, now a part of Cordwood Landing County Park, Gully Landing, and Woodhull Landing. The beach was a little over a half a mile from this spot at the corner of North Country Road.

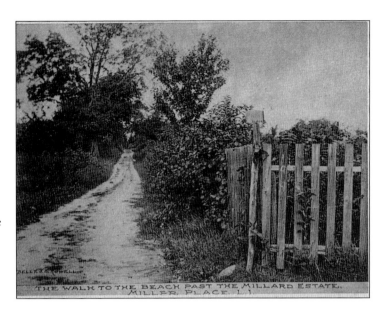

THE WALK TO THE BEACH PAST THE MILLARD ESTATE, MILLER PLACE, L.I.

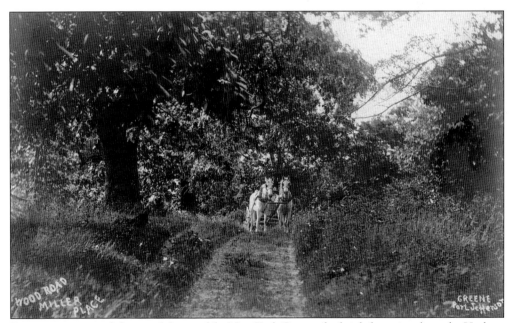

WOOD ROAD MILLER PLACE

GREENE Port Jefferson

Farmers transported the wood destined for New York City or the brick factories along the Hudson River from the woodlots to the main roads and then to the landing roads. Wood roads were private roads over a person's own land. Today these roads are still visible in wooded areas, though many have fallen into disrepair and appear to be no more than footpaths.

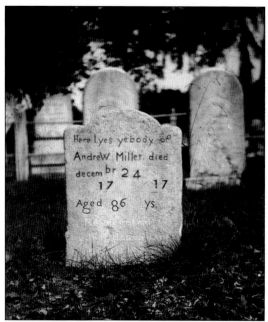

Andrew Miller, the first of the Millers to live in the area and the first permanent settler, came from East Hampton. He was a cooper by trade. Although Miller died in 1717, the tombstone bears a later inscription, indicating the family moved it to SeaView Cemetery, Mount Sinai, in the 1800s. The top portion of the gravestone has eroded but may have shown the "death's head" etching popular at this time. (Courtesy of Margaret Davis Gass.)

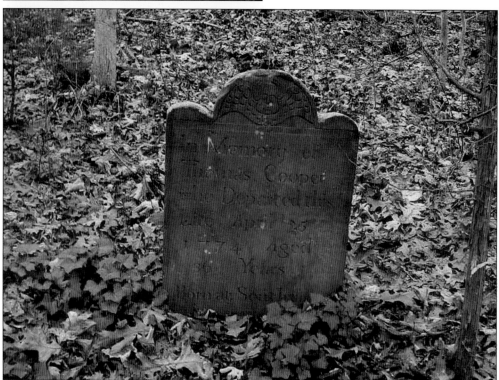

A carpenter from Southampton, Thomas Cooper came to Miller's Place to build a barn for Samuel Hopkins. According to tradition, he fell off the roof and was buried in the family cemetery, the only remaining burial ground of its kind in Miller Place, located near North Country Road, east of Pipe Stave Hollow Road. The cherub, visible on this 1774 stone, became popular along with the ideas of the Great Awakening.

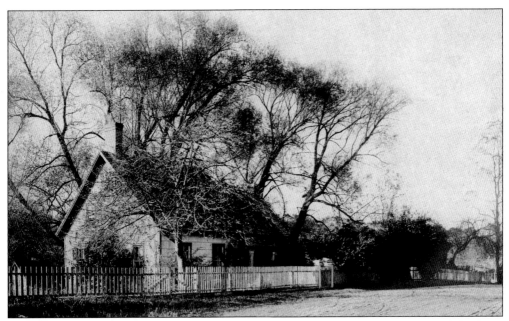

The house of Timothy Miller, grandson of William Miller, is the only true "Cape Cod" house in Miller Place. The entry has a Dutch door similar to that of his grandfather's. The house had a series of owners after being sold out of the family in the mid-to-late 19th century. Abandoned in the 1970s, the house has now been restored by its present owners.

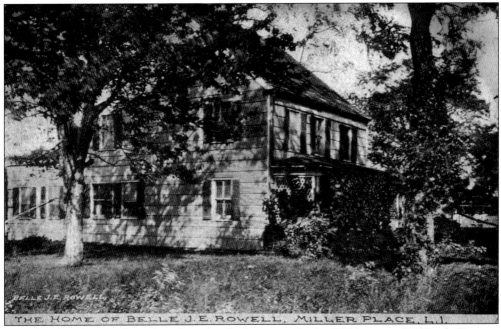

Daniel and Bethia Hawkins, from Setauket, had no sons. So the 1810 house at 111 North Country Road passed to one of their grandsons. The Hawkins house has an artistic heritage. A longtime renter, Belle J. E. Rowell, daughter-in-law of Rev. Morse Rowell, took up photography and made postcards of Miller Place to support her family. Arthur and Linda Calace purchased the house in 1995 and donated it to the Historical Society.

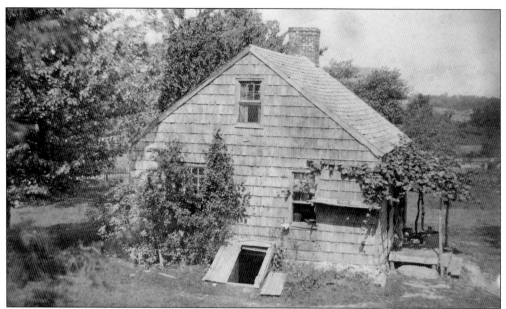

The Burgess Davis House was built around 1820, where the North Country Road Middle School stands today. The open door leads to a root cellar, where the family would store vegetables and jams. At the time of this photograph, in the early 1900s, Burgess Davis had passed away. The women took in laundry to support the household. A water barrel and white enamel basin are visible on the porch.

The Burgess Davis family sits for a formal portrait outside its house, from left to right, are Hannah Emiline Davis, daughter of Burgess and Mary and mother of Addison P. Davis; Mary T. Davis, widow of Burgess; Sarah Amelia (Davis) Lucas, daughter of Burgess and Mary; (standing) Alice Lucas, daughter of Sarah Amelia (Davis) Lucas. Note the simple stone-slab steps.

A dam, no longer in existence, built across the stream that flowed down Pipe Stave Hollow, created a pond on the Hopkins's farm. The pond provided water for crops and livestock. In the winter, the Hopkins family would harvest ice from the pond and store it in a large "ice building" on the island to the right of the pond for summer use and sale.

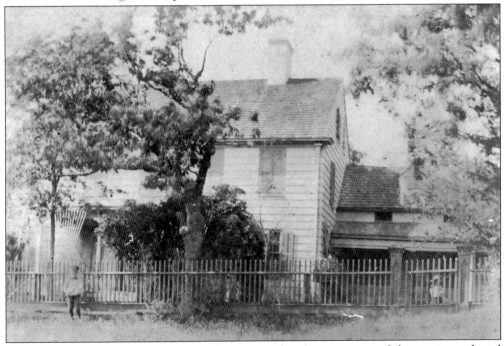

The Hopkins homestead, built in the early 1800s, replaced or incorporated the previous colonial house. The Hopkins family owned this property, located on Pipe Stave Hollow Road and extending to North Country Road, from 1754 to the 1940s. The fence has been removed but otherwise the facade remains virtually unchanged to this day. (Courtesy of Margaret Davis Gass.)

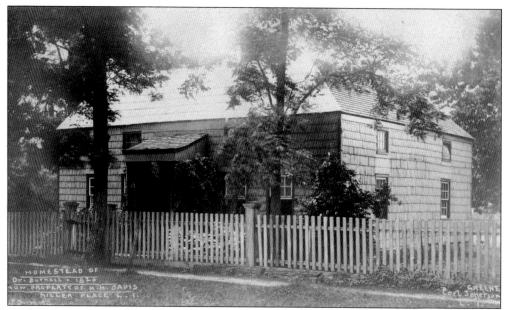

Dr. Sereno Burnell's 1820 shingle house, with a simple two-column portico and "lie-on-your-belly windows" (to see out, one must lie on his or her stomach), is a curious mix of styles. Originally from Massachusetts, Burnell became a respected citizen of Suffolk. One of his children followed his career path, attending New York University Medical School, and one of his grandsons, Orlando Burnell Davis, founded the O. B. Davis Funeral Home of Port Jefferson. In 1930, Hewlett H. Davis Jr. demolished the structure and built a new house.

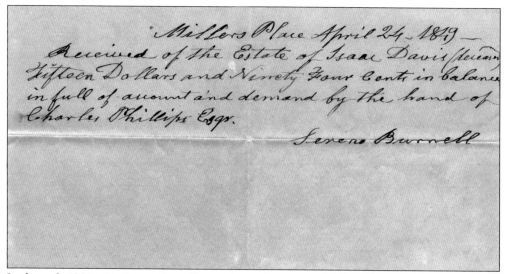

In the early 1800s, Dr. Sereno Burnell served as a physician in Miller's Place and the surrounding communities. Without formal billheads, Burnell used a piece of writing paper to note receipt of payment. In this example, Burnell notes that on April 24, 1849, the estate of Isaac Davis settled his outstanding bills.

Built by William Hopkins around 1820, the Capt. Alfred M. Davis house at 123 North Country Road is a popular design of the era. The wraparound porch was a later addition but has since been removed and the original stoop restored. One unique feature is the fan-light transom over the door—the only one of its kind among the historic homes of Miller Place. Richard Miller, an avowed Tory, loyal to the king of England, originally owned the property. Following the Revolution, local officials confiscated and sold Tory properties, and Nathaniel Davis purchased this land. Nathaniel's son, Capt. Alfred M. Davis, went to sea as a young man but later returned to become a farmer. This house also served as one of the many post offices in Miller Place. The house remains in Captain Davis's family and is currently the residence of one of his great, great granddaughters.

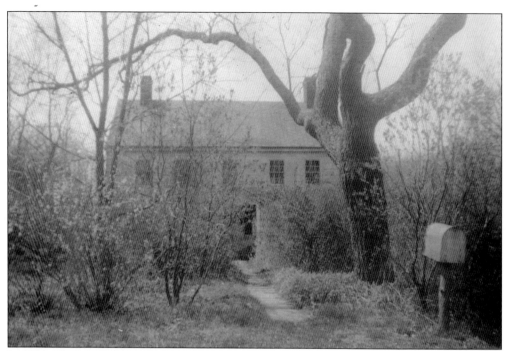

In 1776, Thomas Helme was named to the committee of safety to monitor Tory activities. To accommodate his grandchildren, his three sons having passed before him, the 80-year-old Helme built the current Federal-style structure in 1812. The property at 208 North Country Road remained in the family until 1957. The chimneys twist in the attic to appear symmetrical on the roofline. (Courtesy of Margaret Davis Gass.)

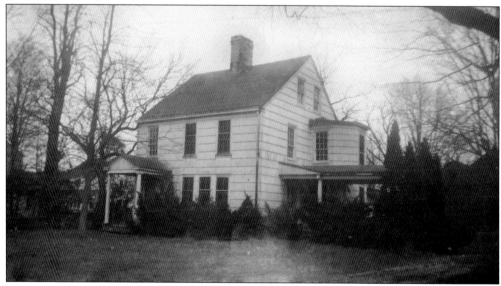

Horace and Eliza Hudson built this house at 199 North Country Road around 1830. The house served as the post office from 1853 and 1876–1885. Like many properties in Miller Place, the house has had a series of renovations, including French doors and an enclosed porch. The home retains its "beehive oven" in the fireplace. The Miller Place Inn (rear) and John Davis House (front) are visible in this 1954 photograph. (Courtesy of Margaret Davis Gass.)

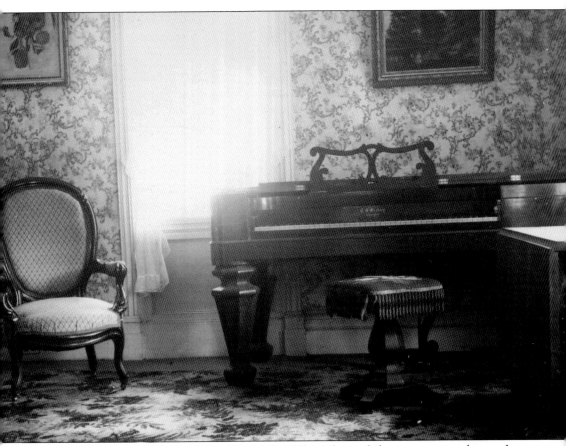

The great grandson of William Miller, Daniel R. Miller inherited the property on the south side of North Country, opposite his parents' house. He married twice. His daughter, Charlotte, married Dr. Charles K. S. Millard, a Union Army Civil War contract surgeon from New York City who served at Fortress Monroe, Virginia. A piano is visible in the parlor of the Daniel R. Miller House. Family evening performances were common entertainment in the days before widespread use of the radio and television. The family remained at 90 North Country Road until 1946. Another daughter, Martha Miller, wrote a history of the family, a part of which was published in *A History of the Town of East Hampton, New York* by Henry P. Hedges. (Courtesy of Margaret Davis Gass.)

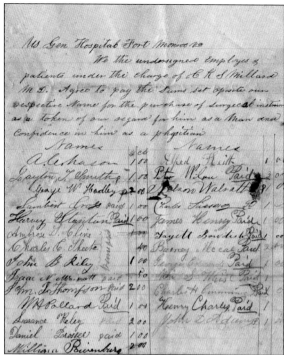

The employees and patients of Dr. Charles K. S. Millard, the Civil War contract surgeon, held him in high esteem and took up a subscription for the purchase of surgical instruments "as a token of our regard for him as a man and confidence in him as a physician."

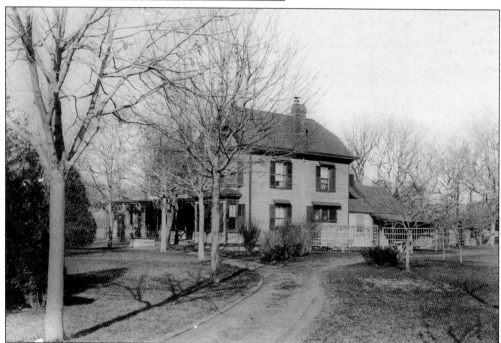

The house at Gully Landing Road (now 11 Lower Rocky Point Road) has been through a series of owners. In this photograph, there are awnings, and a horse block provides ladies in long dresses with a platform for easy entry and exit of carriages. In 1962, Jerome and Mary Coyle bought the house as their summer residence and then, in the 1980s, opened the first bed-and-breakfast in Miller Place, calling it Windsong. (Courtesy of Warne Randall.)

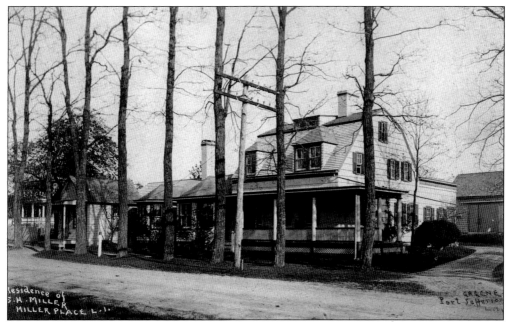

Deacon Charles Miller built this 1824 house at 154 North Country Road on property purchased from his father-in-law, Nathaniel Davis. The house has one of only two Gambrel roofs in Miller Place. Miller lived significantly longer than his parents, who died in a yellow fever epidemic in 1798 when he was just barely two, leaving him and his three older sisters orphaned.

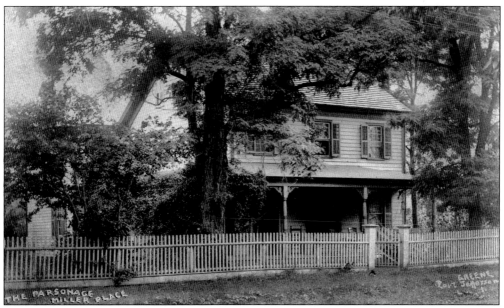

The parsonage at 160 North Country Road built in 1838 has served as the home of the minister of the Congregational Church of Old Mans, Miller's Place, and Rocky Point. The women of the church hosted lunches, dinners, and bake and fancy goods sales. Previous ministers would vacation at the parsonage, and the house is still the home of the minister of the church.

At the Miller Place Academy private school, boys and girls, between the ages of 10 to 20 received instruction beyond the basic courses available at public school. The private academy was open from 1834–1868. As the school's reputation grew, students from all over Long Island enrolled, creating a demand for homes willing to take in young boarders. Isaac Hudson designed the two-room schoolhouse in the late Federal style.

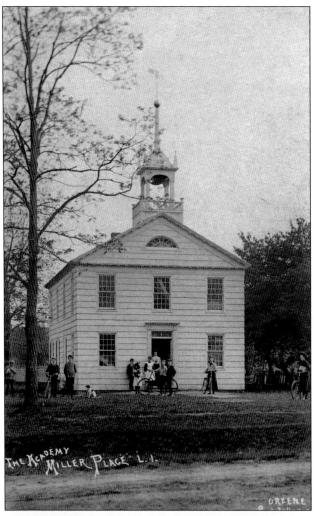

THE ACADEMY MILLER PLACE L.I.

GREENE

Community members financed construction of the Academy by subscription, demonstrating an early village commitment to education. Thomas Helme, secretary of the Academy committee, wrote this receipt to Charles Miller on a scrap of paper. After closing as a private school in 1868, the Academy served as a public school until 1937, a meeting center for local organizations, and a polling place. Still privately owned by the descendants of the original shareholders, the Academy provides library services.

MILLERS PLACE ACADEMY,

Suffolk Co. L. I.

This Institution is pleasantly situated in the midst of a quiet, industrious, and moral community; readily accessible from New York by Rail-Road and Stage, through Medford Station; or by Steamer, through Port Jefferson. The village is unusually free from many of those temptations to evil, which have proved so disparaging and ruinous to youth; and affords peculiar advantages for a healthful developement, in *moral*, intellectual and physical culture. Instruction will be *practically* thorough, both in ancient and modern languages, but *especially* in those sciences and more common branches of education that belong to business and social intercourse, and particularly will pupils be trained to a formation of correct habits of thought and action, that they may be come good and effective citizens.

The year is divided into two Terms of twenty-two weeks each. The Winter term will open on the first Monday of November.

The Terms per Quarter of 11 Weeks, are

Common English - - -	$4,00
Higher do - - -	5,00
Ancient Languages - - -	6,00

Extras.

Modern Languages, each - - -	$2,00
Drawing - - - -	3,00
Painting in Water Colors - -	4,00
do do Oil - - -	8,00
Crayoning - - -	5,00

The Trustees have secured the services of Mr. J. A. Thomas, an accomplished gentleman, graduate of Union College, and of several years experience; with his wife, a graduate of Troy Seminary.

A trifling expense from 40 to 60 cents will be incurred per Quarter.

By order of the Trustees,

SECRETARY.

Millers Place, 186

This flyer extols the virtues of Miller Place as a "quiet, industrious, and moral community . . . unusually free from many of those temptations of evil" and describes the course offerings for the coming year at the Academy. In addition to the courses in the English language and ancient languages, students could add studies in modern languages and art. This classical education was designed to prepare students for futures in business or further studies at universities and for their roles as "good and effective citizens." The teachers for this term were Mr. J. A. Thomas, a graduate of Union College, and his wife, a graduate of Troy Seminary. When classes were not in session, the building served as a location for Sunday school for the Mount Sinai Congregational Church, fund-raisers, and the Forum. In 1912, Mrs. Martha Wentworth Suffern, city vice chair of the Suffrage Party, spoke to a crowd of 80 people on the topic of women's suffrage.

Built in 1835, the Conklin Davis Complex at 205 North Country Road is the last surviving village cluster of 19th-century farm buildings. Davis first built a smaller house on the property, which served as a general store and a caretaker's house after the construction of the larger, which featured two and a half stories and five bays. The house remains in the family. (Courtesy of Margaret Davis Gass.)

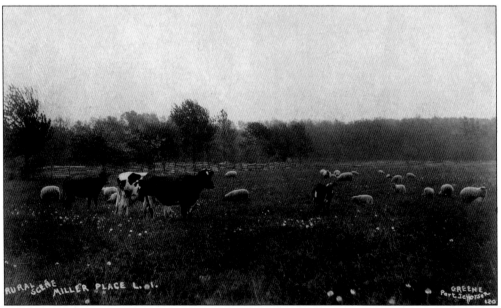

Miller Place remained a farming community well into the 20th century. The original settlers built homes along North Country Road and farmed the land extending behind the houses. Cows and sheep were an essential part of every farm and roamed free for most of the 17th and 18th centuries. Prior to the 1800s, fences were used to protect crops. By the time of this photograph, farmers used fences to pen in livestock.

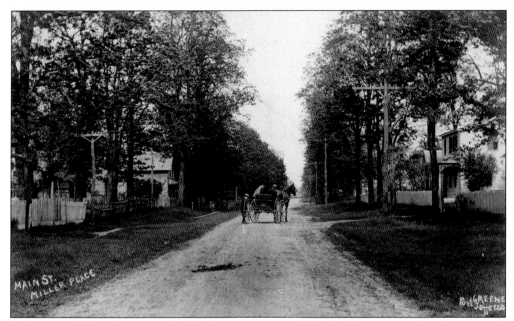

In this view of North Country Road looking east, Capt. Alfred M. Davis house (left, foreground), the partially obscured Hewlett H. Davis store (left, background), and the Erastus Brown house (right), which is now the office of John Ray, are pictured. In the summer, the town sprayed oil on the roads to keep down the dust on this road. The road and its grassy shoulders are now paved with asphalt.

Sylvan Avenue survived as a one-wagon-width road through the woods into the 20th century. Farmers brought wood from the woodlots along this road to the landing roads that led to the beach. Hoof prints are visible along the road. This postcard from around 1900 shows the road before the town widened and straightened it in 1911 and 1933.

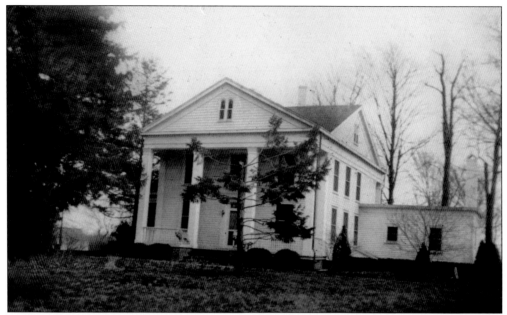

Built in 1841, the Reverend Ezra King House, which replaced an earlier structure, has an antebellum-southern-neoclassical design. The house was sold out of the family in 1869 but continued as a working farm under successive owners. In 1943, John Vasselaros purchased the property as a summer vacation home. (Courtesy of Margaret Davis Gass.)

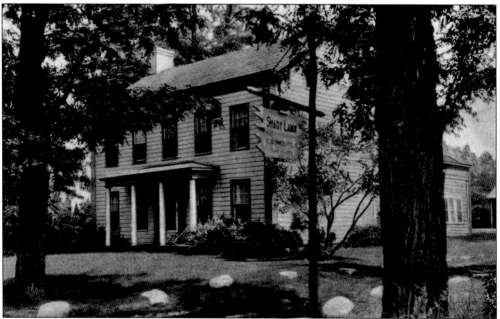

When Sylvester G. Randall left for the California gold fields for a second time and did not return, the house at 172 North Country Road became the Shady Lawn boardinghouse. One son, John S. Randall, moved to Mount Sinai in 1884, and so Mrs. Sylvester Randall and her other son, Sanford, took in boarders. Family-owned until 1921, the house was again purchased by a descendant in 1985. (Courtesy of Margaret Davis Gass.)

Sometime after he married in 1860, John M. Brown added significantly to the original Andrew Miller house, incorporating but obscuring the original structure. Different colors of slate give the roof its stripes. Today the outbuildings are still present, and the front entrance has been enclosed. (Courtesy of Margaret Davis Gass.)

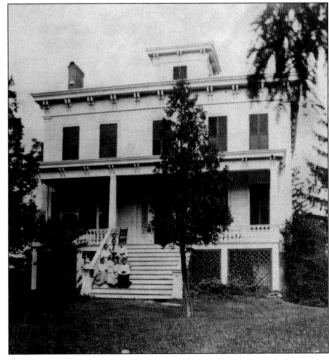

Joseph Rowland trained trotter/pacer horses and built this house on North Country Road sometime after 1845. Most of the sitters in this 1900 photograph are unidentified, with the exception of Marguerite Tunstall (on the post), Ethel Tunstall (bottom row, third from left), and ? Hansem wearing ribbons (middle of the second row). After the house burned in 1920, the barn and outbuilding were incorporated into the Miller Place Inn. (Courtesy of Margaret Davis Gass.)

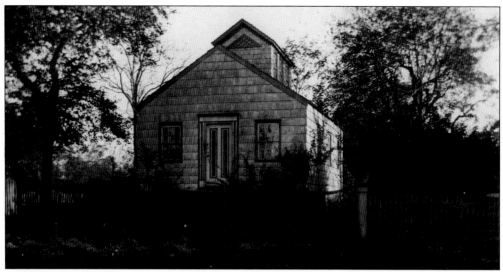

This one-room schoolhouse, built in 1837, accommodated all grades below the high-school level until the early 1900s. Despite proposals for converting the school to a community center, it was demolished in the early 20th century—only the sandstone foundation remains. The fences mark the boundaries of Sylvester G. Randall's first (170 North Country Road) and second (172) houses. (Courtesy of Margaret Davis Gass.)

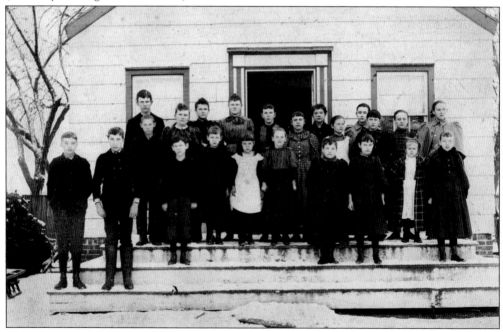

Note the snow on the ground and the firewood outside the building to the left in this January 17, 1895, photograph. The students are, from left to right, (first row) Merritt J. Hopkins, Archie V. Luce, Louis Davis, Katherine W. Davis, Leila M. Davis, Minnie Underwood, Eva C. Jones, Norma Hazeltine, Ray Hazeltine, and Isabel T. Davis; (second row) Henry Davis, Frank Keeler, Giuletta G. Hutchinson (teacher), Anna Newton, Elizabeth Newton, May Davis, Minnie Wade, Martha J. Overton, Lida Underwood, Grace J. Miller, Bertha Taylor, Hattie Davis, and Alila May Miller. (Courtesy of Margaret Davis Gass.)

Two

By the Seashore
1880–1910

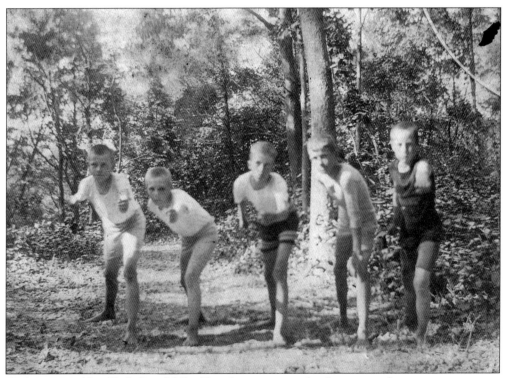

With access to New York City, Miller Place became a popular destination for summer recreation. On Sylvan Lane, the Boys Camp of Grace Church, most likely in Jamaica, Queens, drew children for fresh air and exercise, in 1894 and 1895. At this time, Sylvan Lane was a pathway to the property. Pictured here, five boys are ready to start a race.

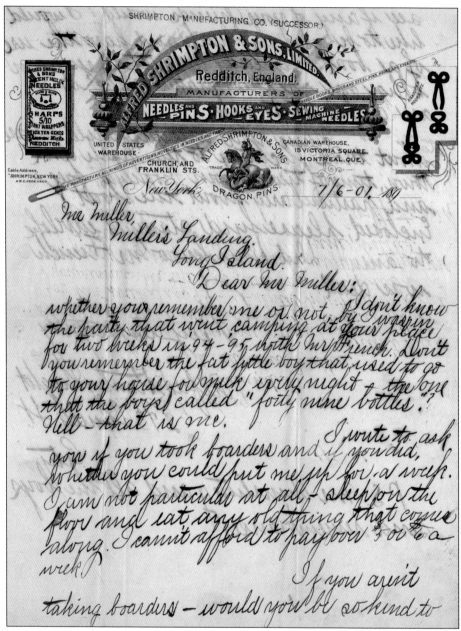

Sylvan Lane was home to a boys camp in 1894–1895. A letter from a former camper, Alfred Stanley Wright, reveals his nostalgia for his summers in Miller Place. The letter reads, in part, "Dear Mr. Miller: I don't know whether you remember me or not. I was in the party that went camping at your place for two weeks in '94–'95 with Mr. French. Don't you remember the fat little boy that used to go to your house for milk every night— the one that the boys called 'forty nine bottles?' Well—that is me. I write to ask you if you took boarders and if you did whether you could put me up for a week. I am not particular at all—sleep on the floor and eat any old thing that comes along. I can't afford to pay over $3 or $6 a week." Wright may have received his desired response as Samuel Miller did host visitors during the summer. Since there were no hotels in Miller Place at the time, taking in boarders was a common practice among homeowners of the area.

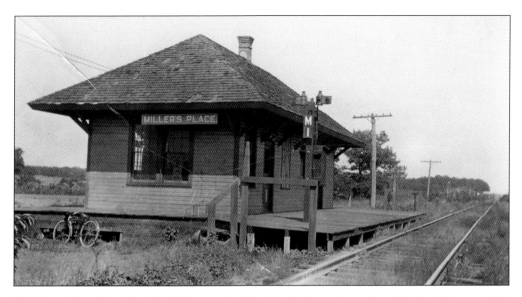

The Long Island Rail Road (LIRR) extended the Port Jefferson branch to Wading River in 1893, including a Miller Place Station built in 1894 on the east side of Sylvan Avenue, between present-day Echo Avenue and 25A. The station burned twice, once in 1903 and again in 1934. Where the tracks once ran lays the current Long Island Power Authority (LIPA) right of way. In addition to passenger trains, freight trains carried vegetables, such as cabbage and turnips, wood, and telephone poles. In the photograph below, young women bound for the Holiday House arrive at the Miller Place Railroad Station. Various wagons and coaches are waiting to take them to boardinghouses in Miller Place and Mount Sinai. The horse and carriage of the photographer, A. S. Greene, are to the right of the picture. (Above photograph courtesy of Margaret Davis Gass.)

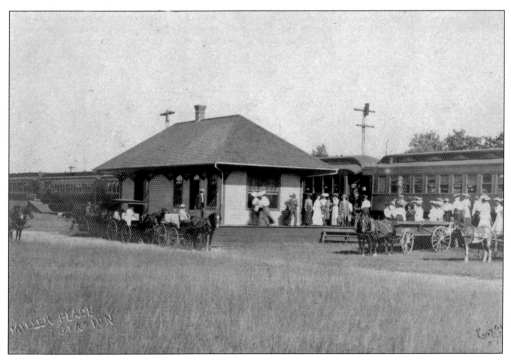

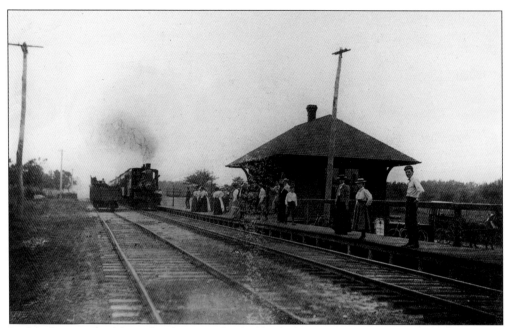

In this photograph of the railroad station, the double track is visible. The passenger track lay closest to the station. On the farther side, to the left, a freight train is hauling wood. Bicycles, increasingly popular in the 1890s, are leaning up against the side of the station. For passengers without other means of transportation, a horse-drawn taxi awaits. (Courtesy of Margaret Davis Gass.)

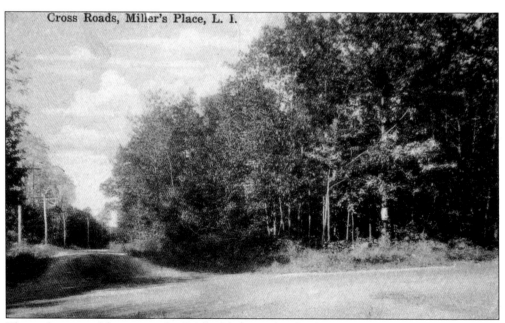

Cross Roads, Miller's Place, L. I.

This early image of the crossroads of Miller Place Road and today's State Route 25A, looking south, shows evidence of Miller Place's growth. Heavily wooded around 1900, today there are two gas stations at the corners, and the road is now four lanes wide. (Courtesy of Margaret Davis Gass.)

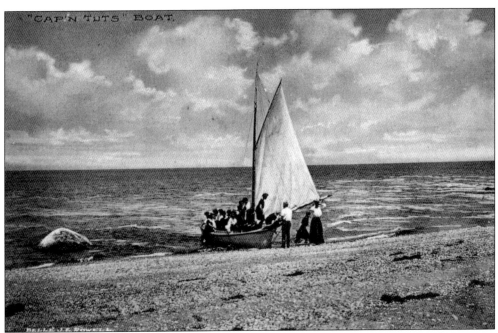

"CAP'N TUTS" BOAT.

Sailing was a popular summer recreation for the local residents and many vacationers who came to Miller Place beginning around 1900. Local men would take groups, including Christian Endeavor, the Forum, and the Holiday House girls, on sailing excursions on the Long Island Sound. Captain Tuthill, known as "Captain Tuts," owner of the vessel and shown in this photograph, had a movable centerboard that allowed landing on the beach.

Bathing in the sea's salt water was thought to have curative powers as early as the 17th century. In the United States, the railroad popularized this pastime for the middle classes. In this 1897 photograph by E. S. Hiscox, the bathers are using umbrellas to protect the skin from burning or tanning. (Courtesy of Margaret Davis Gass.)

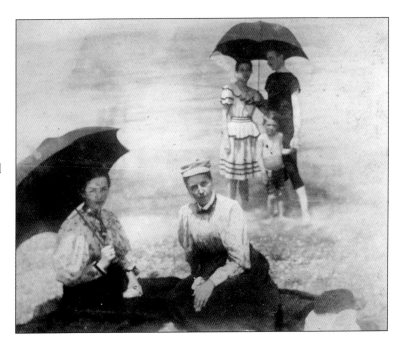

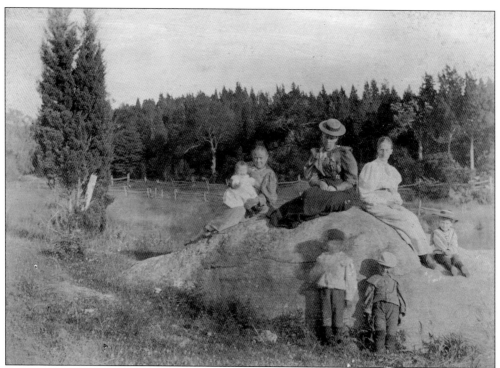

Vacationers are posing on a rock during low tide in this 1897 photograph. From left to right are (first row) Selah Hiscox, Eben Hiscox; (second row) Mrs. Meldrum holding infant Mabel Hiscox, Mrs. E. S. Hiscox, Mrs. J. A. Hiscox, Eben Hiscox, and David Hiscox. Due to overgrowth, this rock is no longer visible from the road. (Courtesy of Margaret Davis Gass.)

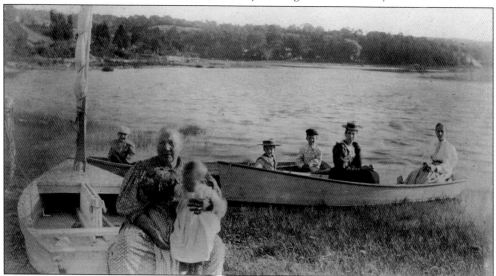

These vacationers pose in boats on the harbor. In the foreground, Mrs. Meldrum is holding the infant Mabel Hiscox. From left to right, seated in the other two boats are Eben Hiscox, David Hiscox, Selah Hiscox, Mrs. E. S. Hiscox, and Mrs. J. A. Hiscox. In the background of this 1897 photograph is the farm of James H. Hopkins, nephew of Samuel J. Hopkins. (Courtesy of Margaret Davis Gass.)

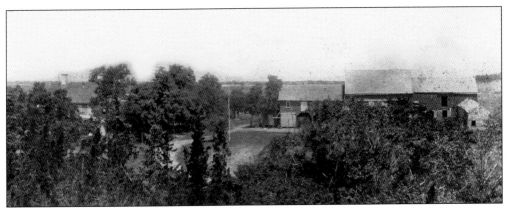

Miller Place remained a primarily rural community around 1900. At the center of the extensive complex of barns on the Hopkins farm is the original 1700s barn. The doors face the south to block the north wind coming off the Long Island Sound. The center barn and the carriage shed to the left are the only remaining outbuildings. (Courtesy of Margaret Davis Gass.)

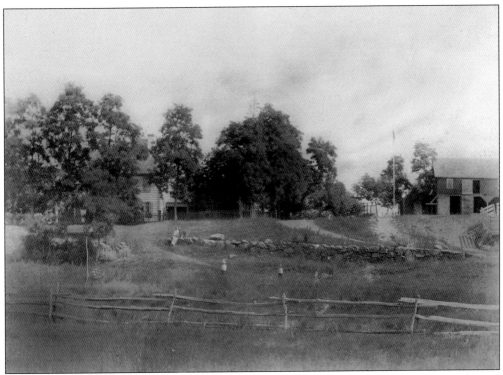

Looking north, the east end of the Hopkins house and the west end of the barn complex are pictured. Breaks in the stone wall, visible in the foreground, allowed for passage along the roads leading to and from the house and the barns. The fence around the house is to keep out livestock and their waste. (Courtesy of Margaret Davis Gass.)

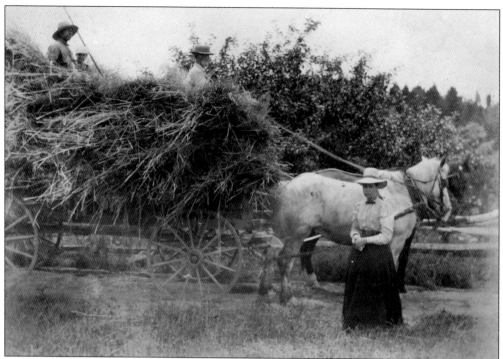

Before the invention of baling machines, hay was collected loose and stored in the barn's "hay maw." In this photograph, Samuel J. Hopkins is bringing a load of hay to his barn. Pictured, from left to right, are an unidentified farmhand, Selah Hiscox, Samuel J. Hopkins, and Mrs. E. S. Hiscox. (Courtesy of Margaret Davis Gass.)

Even the most successful farmers rented rooms to vacationers to supplement their income. In this photograph by E. S. Hiscox, Samuel J. Hopkins drives by on a horse-drawn, hay-cutting machine while vacationers stand inside the fence of the Hopkins Homestead. (Courtesy of Margaret Davis Gass.)

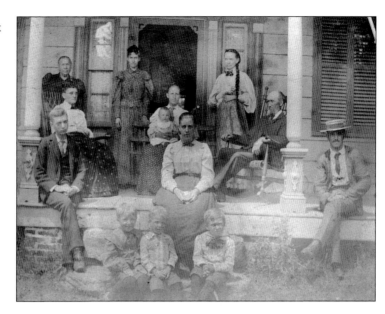

Members of the Hiscox family and other vacationers relax on the front porch of the Hopkins Homestead. The porch, a structure that became popular at the end of the 19th century, was not original to the house and is no longer there. One gentleman is sitting in a rocking chair. Standing to the far left is Mrs. Meldrum; the others are unidentified. (Courtesy of Margaret Davis Gass.)

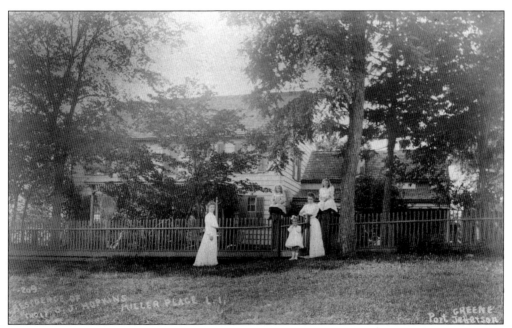

Samuel J. Hopkins and Sarah (Hallock) Hopkins had four sons, three of whom moved away from Miller's Place. The brothers would return with their families for holidays and summer vacations. Posing here, from left to right, are Lulu (Howland) Hopkins; Dorothy Hopkins; Lucia Hopkins, daughter of Rupert Henry Hopkins and Charlotte (Burden) Hopkins; Eleanor Ruth Hopkins; and Eleanor Howland. Dorothy and Eleanor were the daughters of Philip and Lulu (Howland) Hopkins.

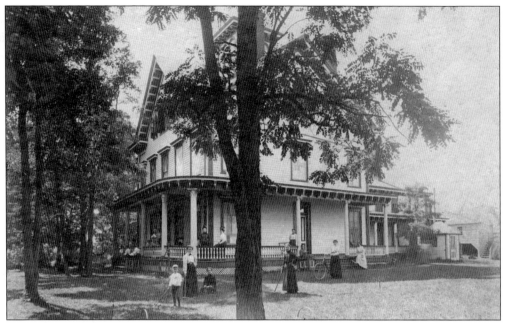

In 1890, the Auxiliary Society of the Association of Working Girls Societies of New York purchased the Jeremiah Rowland house, built in 1852, as a "Holiday House"—a summer retreat for its members. Here young women are shown at various recreational activities: croquet, bicycling, reading, and relaxing on the porch or hammock. Local children often joined in the games.

The Holiday House Barn, an original part of the Jeremiah Rowland farm, was used for dances. Members of the surrounding communities were invited and, during World War I dances, raised funds for the Red Cross. The events continued through the 1950s. The funds raised went towards the maintenance of the Holiday House complex.

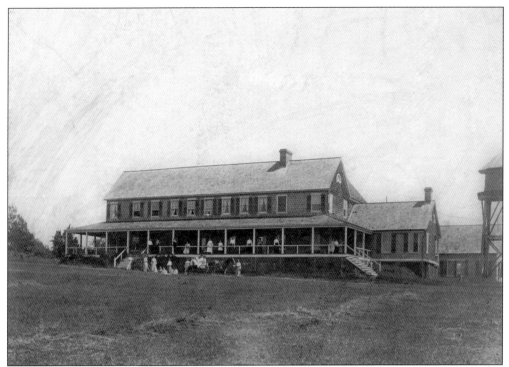

In 1909, the society added the Harbor House farther back on the property. This is a view of the Harbor House overlooking the sound. Here some vacationing young women are seen enjoying themselves on the porch and lawn. The tower to the right of the building supplied the Holiday and Harbor Houses with fresh water. (Photograph by A. S. Greene.)

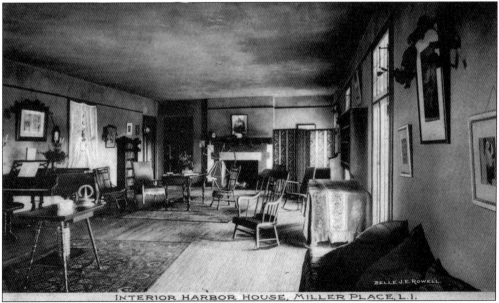

The common living space of the Harbor House included a few seating areas, books, and a spinning wheel that was for decorative purposes only. The highlight of the room would have been the piano, which the young women would have played during evening sing-a-longs.

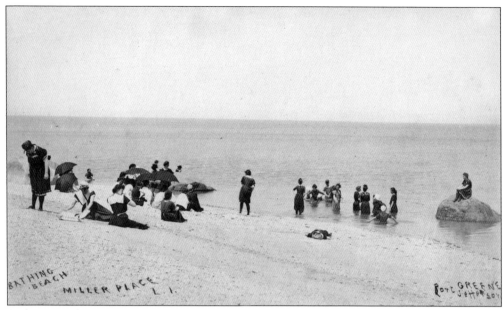

Bathing Beach was part of the draw of this resort destination but few, if any, of the young women at the Holiday House would have known how to swim. Like most vacationers of the era, they would have bathed only for short periods in their wool suits, enjoying the putative curative powers of the water. In between soaks, they would retire to the rocks or the beach, taking care to use an umbrella to prevent tanning.

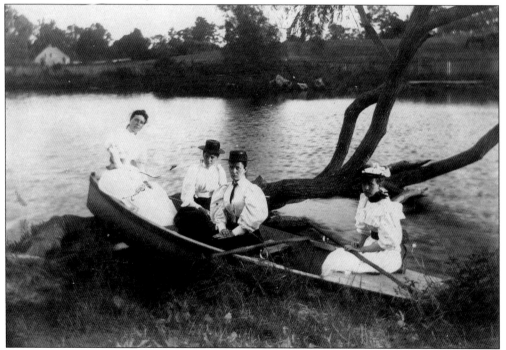

Miller Place Pond, originally a swamp and then blocked off to serve as a watering hole for livestock and crops, eventually provided the opportunity for various types of recreation. A couple of boats were available for Holiday House ladies to row across the pond. (Courtesy of Warne Randall.)

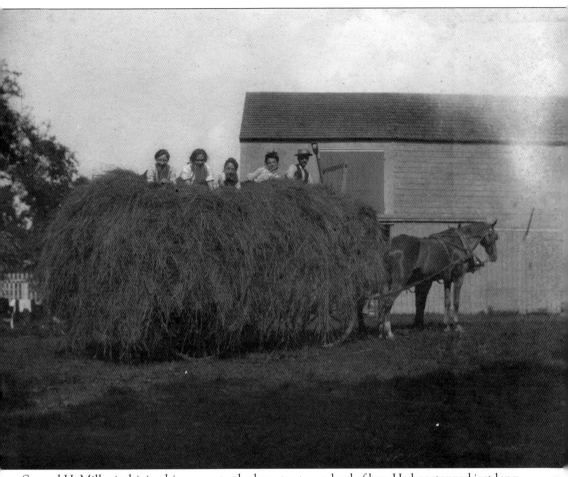

Samuel H. Miller is driving his wagon to the barn to store a load of hay. He has stopped just long enough from his farm chores to take this photograph with a group of young women, most likely from the Holiday House. (Courtesy of Willis White.)

Originally the home of Ebenezer Miller, built around 1760, the Miller Place Ark at 179 North Country Road became a boardinghouse in 1900 when George and Elizabeth Linkletter purchased the property and boarded young women who were unable to secure lodging at the Holiday House. It was dubbed the "Ark" for its large number of boarders.

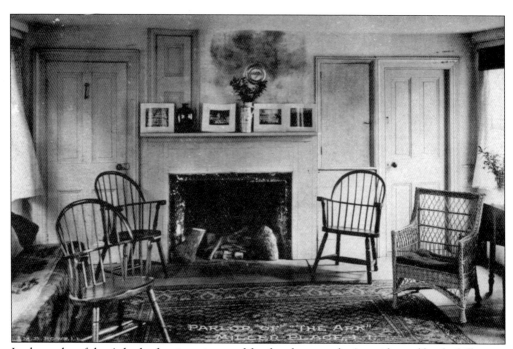

In the parlor of the Ark, the furniture is staged for the photograph. As evidenced by the billowing curtains, the window is open. Although the fireplace was not in use, wood is stacked inside. A decorative tin plate above the mantle covers a stovepipe hole. Above the fireplace, a small door leads to a storage closet.

The house at 168 North Country Road was built for Nathaniel Brown in 1842. Elisha E. Davis, a retired sea captain, purchased it in 1896. During the summer, the Davis family ran a boardinghouse as another alternative to accommodate overflow from the Holiday House. The house remained in the family until 1977.

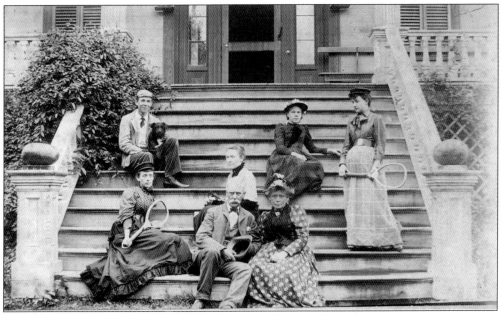

Vacationers relax on the steps of the Joseph Rowland House. The staircase leads to the first floor, which was elevated above the ground. The Rowland House was the only home in the area to have this raised first floor. The house burned down in 1920; this is the current location of the Miller Place Inn. (Courtesy of Margaret Davis Gass.)

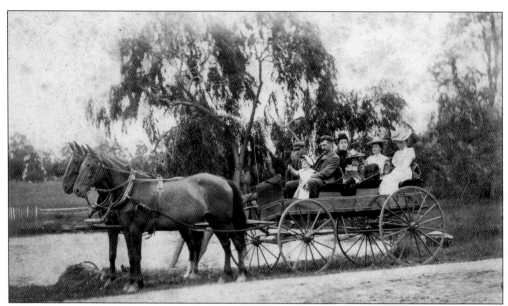

Farmers' wagons served various purposes. In this July 24, 1899, photograph taken on North Country Road adjacent to the pond, Samuel H. Miller has placed seats in his wagon to transport passengers. Seated are, from left to right, (front seat) Joseph C. Hanson; his son, Joseph C. Hanson; (second seat) Mrs. Joseph C. Hanson; her daughter, Florie Hanson; (third seat) Fliece ?, and Annie Barwick.

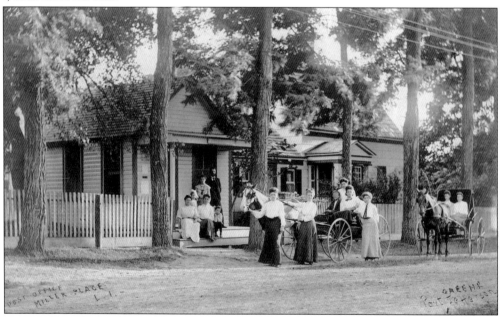

In 1901, Samuel H. Miller was appointed postmaster and ran the post office until 1914 out of this building constructed by Edwin S. Davis until 1914. The post office was attached to the house through a covered passageway. In this photograph, Samuel H. Miller stands on the porch, and the two young women in the carriage to the far right are his daughters, Grace J. and Alila M. Miller. The second horse and carriage belonged to the photographer, A. S. Greene. The other women in the photograph are vacationers staying at the Holiday House. (Courtesy of Warne Randall.)

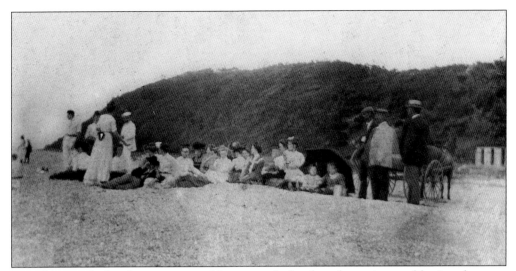

Picnicking on the beach was an enjoyable pastime for locals and vacationers alike. Local groups, such as the Christian Endeavor and the Forum, often organized such outings for their members. Most of the people in this 1902 photograph are focused on something on the water, out of the frame. (Courtesy of Warne Randall.)

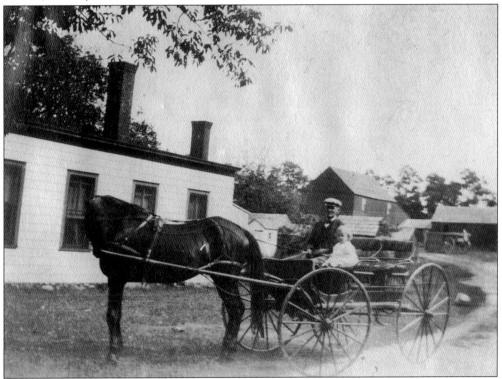

Melville S. Warner gives his niece, Eloise Randall, a ride in front of his property at 178 North Country Road. He is the son of Waldo Warner, who came from Center Moriches. Eloise is the daughter of Melville's sister, Achsa, who married Forrest B. Randall of Mount Sinai. The barn in the background burned in February 1973 during a rash of barn burnings. (Courtesy of Harry Randall.)

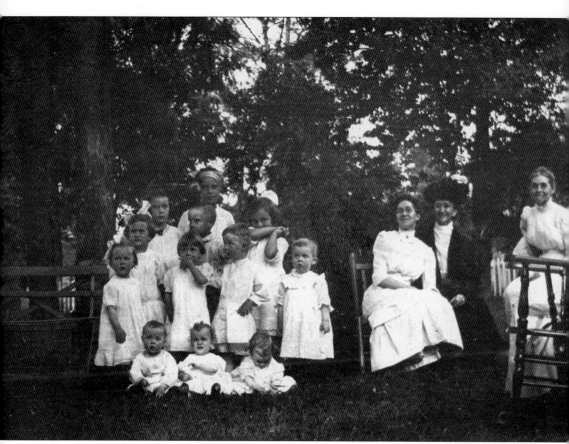

Founded in 1874 to reduce and eliminate the use of alcohol, the Women's Christian Temperance Union (WCTU) had the larger goal of protecting women and children and eventually advocating for their civil rights. According to the WCTU, by 1910, "every state required the teaching of scientific temperance instruction in all public schools." In 1919, partly as a result of the WCTU's national efforts, the states ratified the 18th (Prohibition amendment). In this 1912 photograph, Mrs. Waldo Warner held a lawn party at her house at 178 North Country Road for the WCTU's very active Miller Place–Mount Sinai chapter, founded in 1909. The boys under the age of three are dressed in a frock instead of pants, a common practice. The children are (first row) Claude Tuthill, twins Marjory and Virginia Warner; (second row) Irma Tuthill, Ernestine Hopkins, John Randall, Charles Davis; (third row) Marcelle Hopkins, unidentified, Helen Warner; (fourth row) Eloise Randall and unidentified. (Photograph by Mrs. Alilah Miller.)

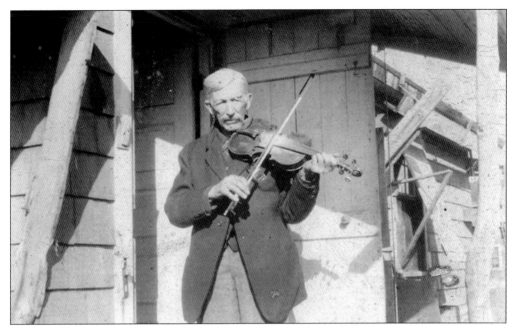

Many well-bred young women of the time learned to play the piano for parlor entertainments, and men would often play the violin or fiddle at dances and parties. Here D. Spencer Millard poses with his violin at the entrance of one of the rear doors of his home, the William Miller House. (Courtesy of Margaret Davis Gass.)

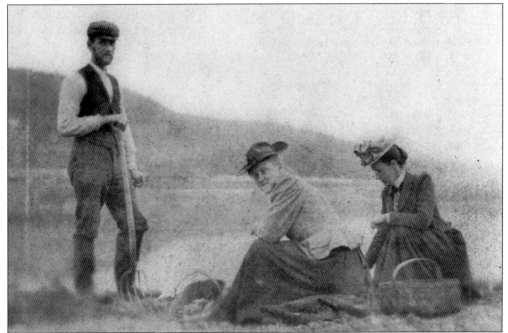

On the Miller property near Mount Sinai Harbor, Samuel H. Miller, his daughter, Alila (right), and Achsa Warner (middle) are gathering potatoes. Mount Misery, present-day Harbor Hills, is in the background. With the arrival of the railroad, potatoes became a big cash crop for Long Island, which had an ideal climate for growing these vegetables. (Courtesy of Warne Randall.)

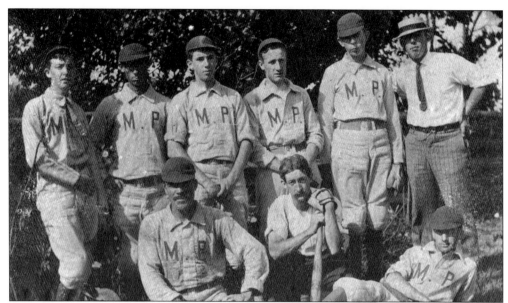

Baseball was very popular on Long Island; each hamlet from Smithtown to Wading River had at least one team, and Miller Place had several. This team is comprised of local boys, as opposed to Mount Sinai's early teams, which were fielded by boys from Brooklyn whose families summered there. Shown in this photograph, from left to right, are (sitting) Louis Doty, Abe Kirby, Archer Davis; (standing) Hewlett H Davis Jr., Frank Keeler, Irving Davis, Richard Bayles, Walter G Davis, and Nathaniel Tuthill. (Courtesy of Margaret Davis Gass.)

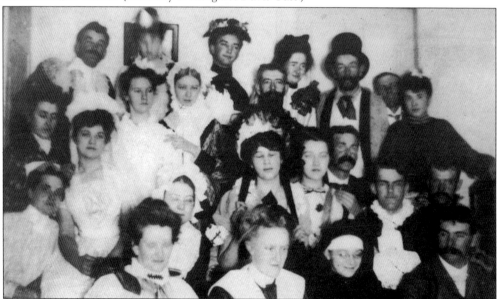

Members of an unknown group, possibly the Forum, are dressed in costume for a theatrical show. In this photograph, taken sometime before 1908, are Grace Miller, Edna Randall, Ernest Hopkins, Edith Stokes, Maud Stokes, Alila May Miller, Anna Davis, Kate Davis, Eva Jones, Merritt Hopkins, Hewlett Davis Jr., Gertrude Stokes, Achsa Warner, Letitia Rowell, Isabel Davis, Chauncey Davis, Edwin Davis, Lillian Stokes, W. D. Warner, Melville Warner, Helen Brooks, Forrest Randall, and an unidentified man.

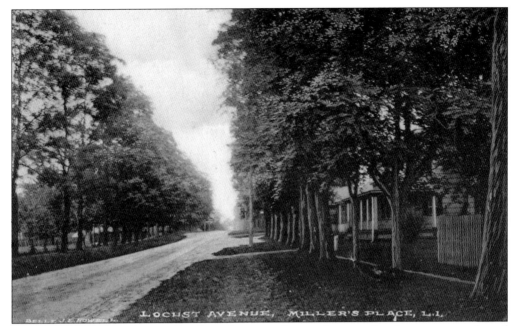

This stretch of North Country Road was known as Locust Avenue after the trees were planted there in the early part of the 19th century. The locusts' shallow root system proved fatal to many of the trees, which fell during the hurricane of 1938. Notice the mile marker on the right side of the photograph.

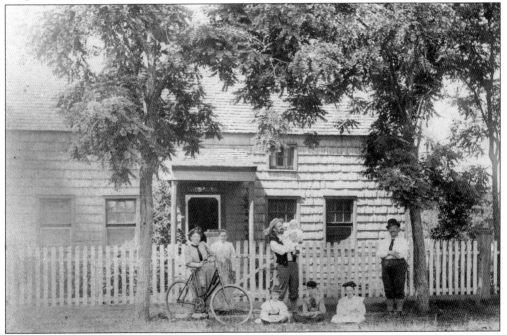

By the time of this photograph, Hewlett H. Davis owned the Sereno Burnell house at 131 North Country Road. For several years, he used the house as a rental property. These boarders are not named, but one of them may be the man who established a tailor shop in the house in 1908. (Courtesy of Margaret Davis Gass.)

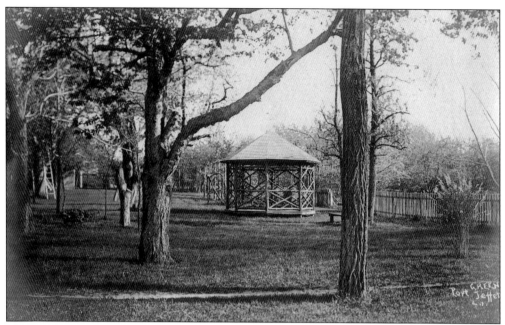

This gazebo, referred to as a "summerhouse," on the Samuel H. Miller property at 154 North Country Road provided a shady spot to sit during the hot summer evenings following a long day of work. The rustic look was popular during the 1890s. This structure remains on the property.

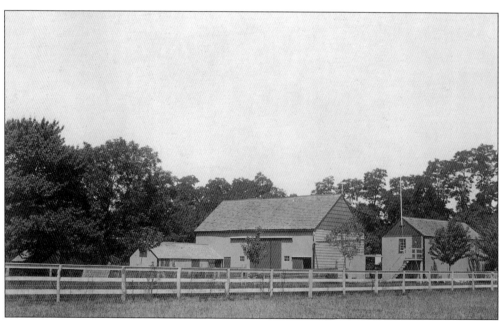

As a working farm, the Samuel H. Miller property at 154 North Country Road had multiple outbuildings. Each served a specific function. These buildings, seen from the Tuthill property, looking west across Sylvan Avenue are, from left to right, a barn for small animals such as pigs, a stable for horses, and a carriage shed. (Courtesy of Willis White.)

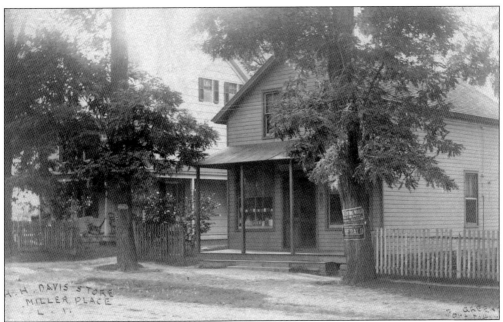

Hewlett H. Davis, postmaster in 1885–1890, 1894, and 1914–1923, purchased this building, originally owned by Erastus Brown, postmaster, in the 1890s. In 1893, he moved it across the street to its present location. The family used half of the building as the post office; a general store occupied the other half. Davis's daughter, Katherine Davis, and then his son, Hewlett H. Davis Jr., followed him in the position of postmaster.

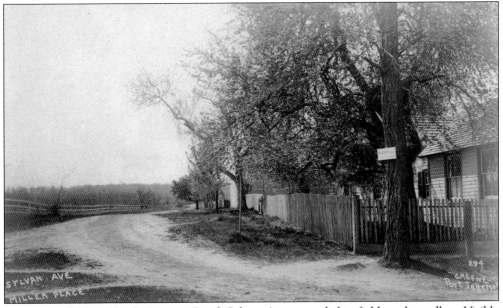

Leading south from North Country Road, Sylvan Avenue ended in fields and woodlots. Visible are the Samuel H. Miller Post Office (right) and house (background). In 1894, the LIRR built the station on the east side of the road. According to the *Port Jefferson Echo* in 1908, the town planned to place warning signs at the intersection "in an effort to induce drivers to slow down their cars in passing through the village."

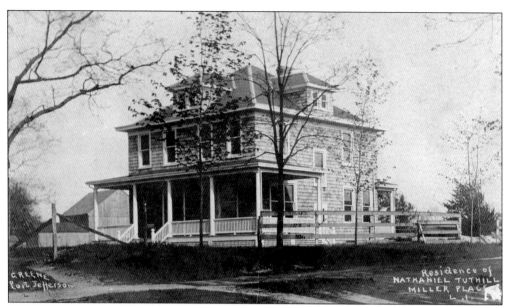

Nathaniel Tuthill and his father, Frank Tuthill, built this house in 1908 for Nathaniel's bride, Alila May Miller Tuthill, on property given to the couple by Alila's parents, Samuel and Alilah (Tillotson) Miller. Standing on the southeast corner of Sylvan Avenue and North Country Road, the home had many of the period's latest conveniences, including a coal-fired furnace, hot water radiant heat, and indoor plumbing. The house remained in the family until 1982.

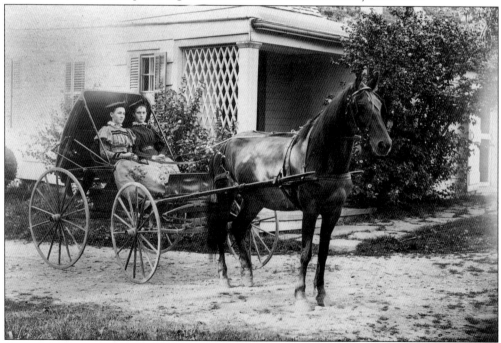

Grace J. Miller is at the reins of Hazel, and Alila May Miller is in the passenger seat of a buggy outside their parents' house. Women, and even older children, could easily hitch and drive these popular and inexpensive, one-horse-drawn vehicles. Buggies were the primary mode of transportation in the late 19th century. Roads were not paved until the arrival of the automobile.

Many of the early Miller Place families became linked by marriage. On February 19, 1912, Aulis Tuthill married Henry Tillotson, who she had known most of her life. Henry died on January 3, 1919, in the 1918 flu pandemic. The sisters, Alila (left) and Grace (middle) Miller, married Aulis's (right) brothers, Nathaniel (left) and Henry Tuthill (middle). Henry Tillotson (right) was a cousin of the Miller sisters.

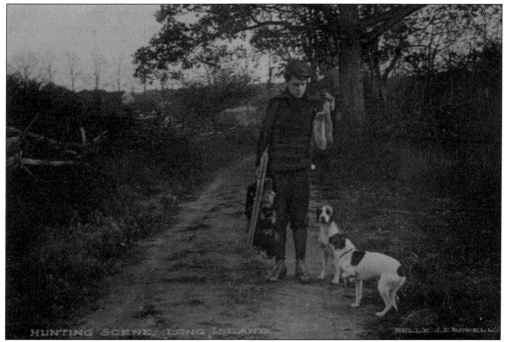

Hunting was a popular pastime for locals and visitors. Most hunters would hunt with their dogs. Local boys would sell the pelts of animals, such as fox and rabbit, to fur dealers in the city. In this photograph, Morse Rowell holds a squirrel in his hand, and the dog in front is Dooley. (Photograph by Belle JE Rowell.)

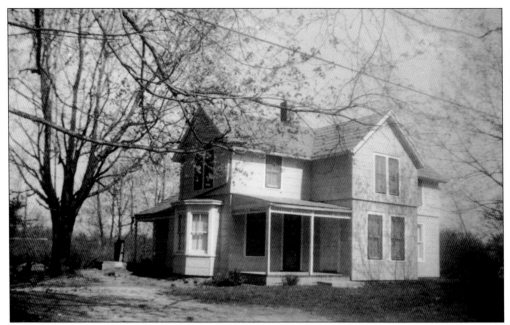

According to tradition, Hannah Rowland built this house at Lower Rocky Point Road and Gully Landing Road after an argument with her husband, Joseph Rowland. The house was built in 1893–1894 and is representative of the late folk-Victorian style. Mass production made machine-manufactured trim more affordable and popular. The house was sold out of the family in 1906.

John Brown privately funded this small building in 1898 for use as the post office. For the first time in the history of the hamlet, the post office was a separate, dedicated structure, rather than inside of the home of the postmaster. This post office was later converted into a bungalow and rented.

Winter Scenes on Beach, Miller Place, L. I., N. Y. S. H. MILLER

During the winter months, vacationers returned home and the local train would operate on a reduced schedule but entertainment still awaited local residents. As snow and ice stacked up on the beach, the picturesque landscape attracted nature-lovers and photographers. When the pond froze over, locals would skate or go sledding on the ice. Other popular winter recreation included horse-sleigh riding and winter hunting for deer or fox. When it was too cold for the outdoors, residents enjoyed talks hosted by the Forum or visiting other hamlets. At Mount Sinai School, entertainments included a Stereopticon show and lectures on exotic places. Also popular were sing-a-longs, dances, and plays at Athena Hall in nearby Port Jefferson, present-day Theater Three.

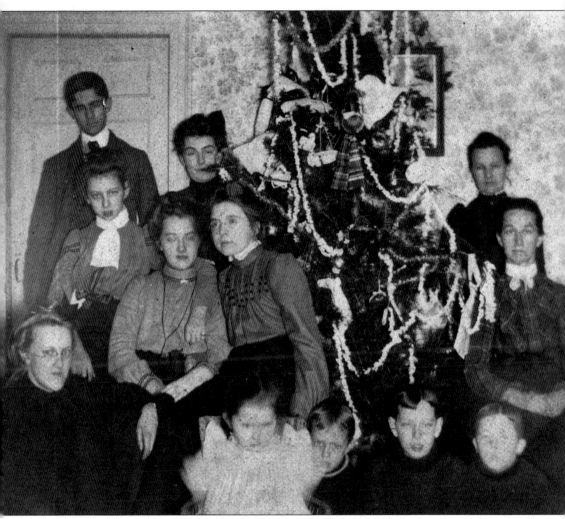

This photograph shows a Christmas decorations gathering around 1900, probably at the home of Capt. Alfred M. Davis. Pictured here are, from left to right, (first row) Achsa Warner; and Sophronia, Lawrence, Fred, and Hewlett Jr.—all children of Minnie and Hewlett Davis; (second row) Kate and Isabel Davis, daughters of Minnie and Hewlett Davis; Marianna Hancock; and Minnie (Davis) Davis; (third row) Edward Wicks, nephew of Minnie Davis; Sadie Hancock; and Angie Davis, sister of Minnie. (Courtesy of Warne Randall.)

Three

BURGEONING SUBURB
1910–1940

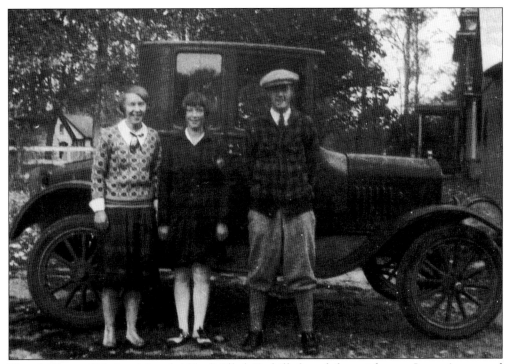

The children of Nathaniel and Alila (Miller) Tuthill, from left to right, are Irma, Anna, and Claude, stand in front of their parents' Model-T Ford. Until 1974, Miller Place had no public high school of its own, and children from the hamlet instead attended Port Jefferson. Bus service to Port Jefferson High School was not available until the 1930s, so parents or neighbors drove the children to school.

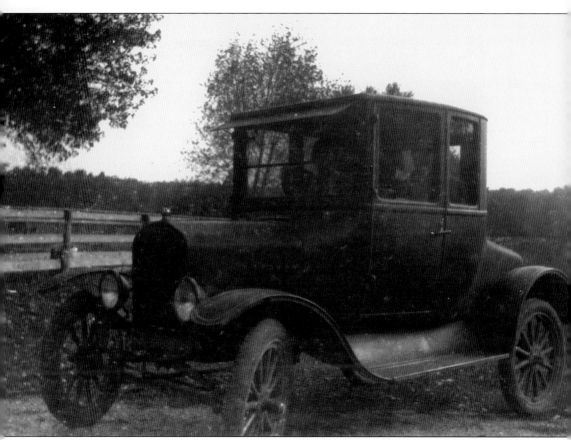

Samuel H. Miller purchased this Model-T Ford, the same one in the previous photograph, and his son-in-law, Nathaniel Tuthill, maintained the vehicle. Someone sits at the steering wheel on the right side of the vehicle, and there are passengers in the back. The Millers took day trips across Long Island in the automobile.

Pvt. Alfred M. Davis, born in 1890, son of Hewlett and Minnie L., joined the 213th Aero squadron on December 12, 1917. The squadron mobilized August 18, 1918, and was part of the 3rd Pursuit Group, made up of four fighter groups and assigned to the 1st Army. Davis saw service in France and was aboard the *Tuscania*, a troop ship, when a German U-boat sunk the vessel on February 5, 1918, in the North Sea. Davis was discharged on June 10, 1919. (Courtesy of Mary Davis Hayes.)

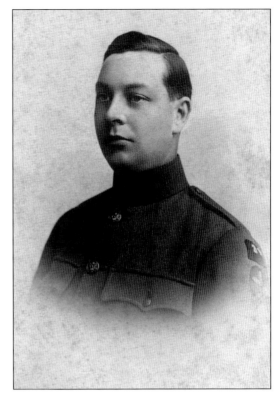

Milton C. Davis (standing in the middle of the back row) took a different path during the war than his relative, Pvt. Alfred M. Davis. Davis graduated from Harvard in 1917, completing his course work in three years. In 1919, he joined 400 young Quakers, Mennonites, and members of other religious denominations to provide aid to the civilian population of Northern France. (Courtesy of Margaret Davis Gass.)

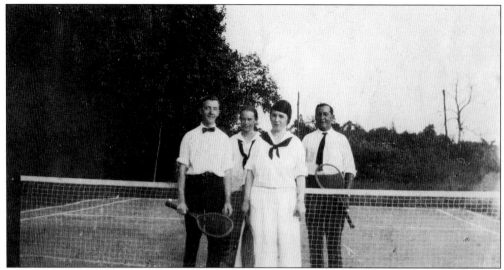

From approximately 1916 to 1920, young people living in the area ran the Tennis Club, renamed the Sport and Study Club in 1918. In addition to playing on a clay court, possibly the one west of Sylvan Avenue on the farm of Samuel H. Miller, the club held winter events, including a fund-raising dance for the Red Cross. Hewlett H. Davis Jr. (left) poses with other members. (Courtesy of Jane Davis Carter.)

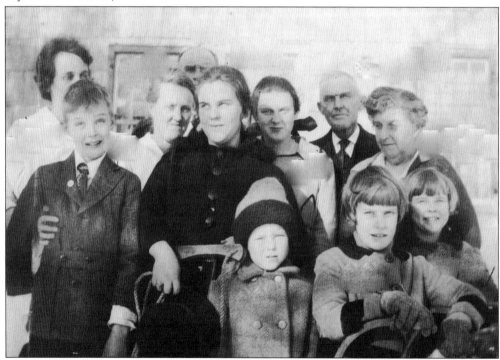

On December 15, 1904, Achsa Warner of Miller Place married Forrest B. Randall of Mount Sinai. This 1918 photograph shows their family, from left to right, (first row) John Randall, Helen Warner, Waldo Randall, Warner twins—Marjory and Virginia; (second row) Gertrude (Stokes) Warner—wife of Melville, Achsa (Warner) Randall, Forrest B. Randall, Eloise Randall, Waldo D. Warner, and Mary T. (Howell) Warner. (Courtesy of Harry Randall.)

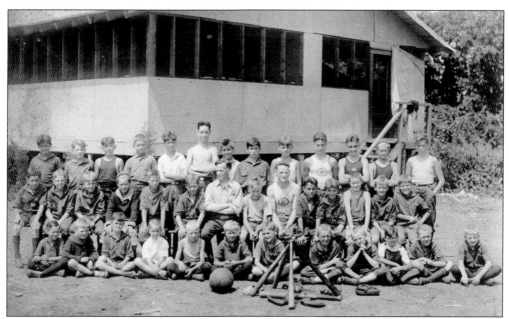

The Harbor Camp for Boys was in session from July through August during the first half of the 20th century. Rupert H. Hopkins, who taught at Staten Island High School, and John C. Atwater, who taught at Richmond Hill High School, ran the camp on the 50 acres of Hopkins's ancestral farm on Pipe Stave Hollow Road. Boys bunked in the large Hopkins house but often camped outside. The Harbor Camp was one of several camps, including Camp Nonowantuc, operating for boys in Miller Place during the 1900s. Boys and counselors are assembled for the 1934 photograph (above). The camp brochure (below) used a birch bark effect for its pages and promised a "whole summer's happiness" and "a square deal." (Below photograph courtesy of Rupert H. Hopkins.)

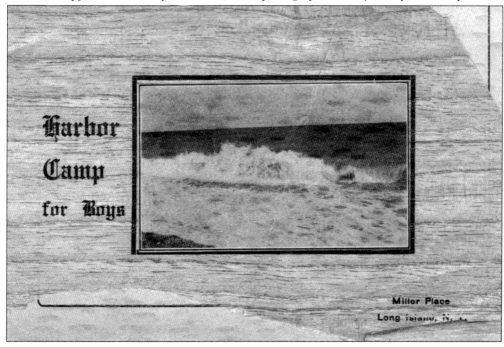

¶ Harbor Camp—a name which will stand to your boy for a whole summer's happiness on the shore of beautiful Long Island Sound, with the most attractive surroundings of field, forest and harbor.

Our Motto

A Square Deal

A GLIMPSE OF THE SURF

The brochure boasted references from area teachers and the vice president of the Franklin Automobile Company in Syracuse. The brochure lists the uniform and equipment requirements and a fee of $200 for the entire season. Activities at camp included swimming, sailing, motor boating, and fishing on the harbor and Long Island Sound. Other outdoor athletics included baseball, basketball, tennis, hiking, quoits, croquet, and track and field sports. Campers enjoyed field trips to area attractions. During rainy days, a music room and reading room were available, and parents could make arrangements for academic lessons. The boys were expected to attend weekly church services. (Courtesy of Rupert Henry Hopkins.)

TERMS

The entire expenses of the camp season are covered by the payment of the single fee of $200. Ten dollars should accompany the application for reservation, one hundred dollars will be due at the opening of the camp, and ninety dollars on August first. Camp Season will be from July 3rd to August 28th.

For further information address—

RUPERT H. HOPKINS, M. S.
Curtis High School
Staten Island

Home Address—103 College Avenue
West New Brighton
Staten Island, N. Y.
Tel. 373-J West Brighton

JOHN C. ATWATER, A. B.
Richmond Hill High School
Richmond Hill, N. Y.

Home Address—663 Stoothoff Avenue
Richmond Hill, N. Y.
Tel. 2733-J Richmond Hill

After June 30
HARBOR CAMP
MILLER PLACE
Long Island, N. Y.
Tel. 14-F-6 Port Jefferson

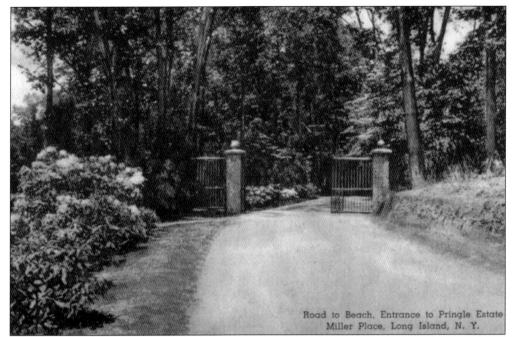

Road to Beach, Entrance to Pringle Estate
Miller Place, Long Island, N. Y.

During the 1920s, more houses were built specifically as vacation homes and cottages. James Pringle built an estate on the cliff, overlooking the Long Island Sound. He spent a portion of the winter in Florida. The entrance gates off Landing Road are still visible through the large rhododendrons from Landing Road.

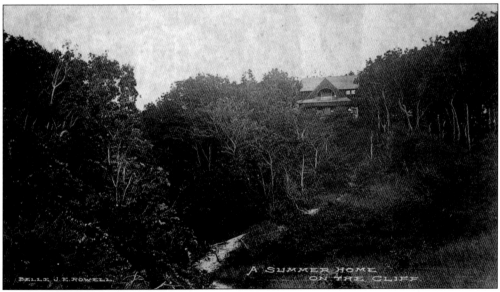

Known at the time as "Qui Si Sana" (here we heal), this cottage on the east side of Miller Landing Road was once owned by Mabel Nelson Trowbridge, wife of Francis B. Trowbridge. Built in 1905, it is one of several constructed by Charles W. Merkle on property he purchased from Samuel H. Miller. Mabel Trowbridge owned an apartment in Manhattan but spent most of her time here, living separately from her husband. In 1922, she shot herself in the neck with a revolver, ending her life. (Courtesy of Margaret Davis Gass.)

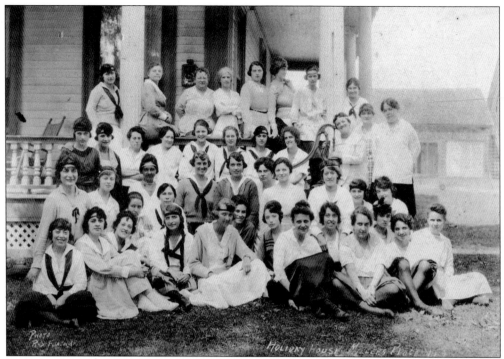

Each summer the influx of young women from New York brought increased activity to the usually quiet hamlet of Miller's Place. More than one young woman married a local man. Note the shorter dresses, headbands, and more casual attire in this group photograph taken in 1917 when compared with earlier photographs of Holiday House girls.

Holiday

Houses

Welcome

You

•

New York League of Girls Clubs, Inc
31 East 37th Street

A 1939 Holiday House brochure describes the "tempting program" planned for "business girls, age 16 years and over," including tennis, swimming, life saving, badminton, volleyball, ping pong, horseback riding, golf, bridge parties, social and old-time parties, hikes, moonlight beach parties, and trips to local towns. Even weekly dances, "to which men are invited," are part of the entertainment. Non-members paid a higher rate.

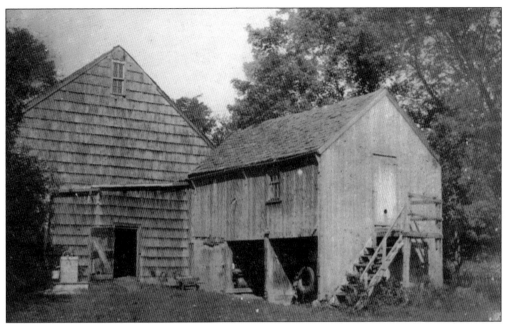

At the William Miller barn at 75 North Country Road, built in the 1800s, a car has replaced the wagon in the shed by the 1920s (above). The stairs at the right access the storage area. Rainwater is collected by a drain along the outside wall, running from the roof to the cistern and then retrieved by hand-cranked chain bucket. In a photograph a few years later (below), the barn is no longer in use and has fallen into disrepair. The stairs are gone, but the rainwater collection is still in place. (Courtesy of Margaret Davis Gass.)

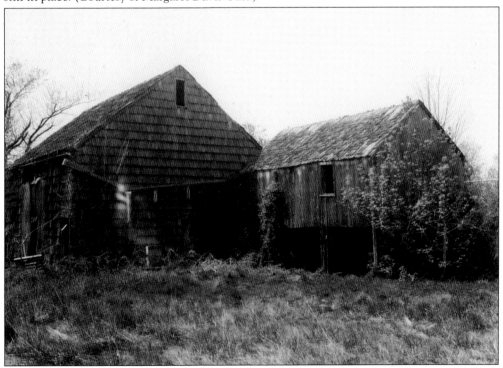

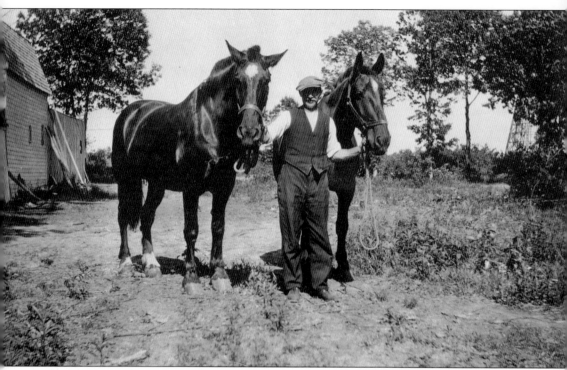

On his 38-acre farm on North Country Road, Joseph Hocker used horses to plow until finally switching to tractors in the early 1940s. In this photograph, he is leading the horses, Charlie and Peanuts. The Hockers raised cauliflower and potatoes for shipment to market, corn for cows, wheat and rye for chickens, and vegetables to sell at the farm stand in front of the house. (Courtesy of Helen Hocker Samuels.)

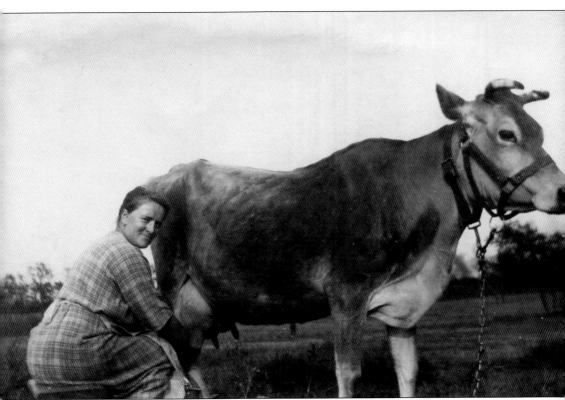

In 1930, the Hocker farm had one cow. In this photograph, Helen (Wolf) Hocker is milking. A good milk cow could produce for 10 to 12 years. Hamlet residents would walk to the farm to purchase the milk in reusable quart glass bottles for 20¢. (Courtesy of Helen Hocker Samuels.)

MILLER PLACE

THE unincorporated village of Miller Place was settled by Andrew Miller in 1659. Andrew Miller, the son of John Miller, was born in Maidstone, England, in 1632. He came to America in the early 1650's, first stopping at Lynne, Mass., and then moving on to East Hampton, Long Island. In 1659 he purchased some land on the north side of the Island and moved to his new property, building his first home near the present pond in Miller Place. Other settlers who moved near him later spoke of living near Miller's place and thus the name of Miller's Place which is still used interchangeably with Miller Place, was originated.

Andrew Miller died in December, 1717, and after him have followed eleven generations of the Miller family, most of whom have lived in Miller Place. The last of the line living in this village today is Mr. Samuel H. Miller, the present President of the Board of Trustees of the Miller Place Academy.

Charles Miller, the great, great, great, grandson of Andrew Miller, was one of the founders and original trustees of the Miller Place Academy in 1834. His son, Edwin Miller, attended courses at the Academy, and five of his children, including Samuel H. Miller, studied there after him. Mr. Elihu Miller of Wading River, L. I., is now the oldest living man who attended the Academy. He is the great grandson of Nathaniel Miller, who was the father of Charles Miller, one of the original trustees. Charlotte M. Miller and Martha H. Miller, both daughters of Daniel R. Miller, also attended the Academy. Miss Mattie A. Millard and D. Spencer Millard, who are now residents of Miller Place, are the children of Charlotte Miller, who married Dr. Charles K. S. Millard. Mrs. Corinne M. Tooker of Port Jefferson is the oldest living person who went to the Academy.

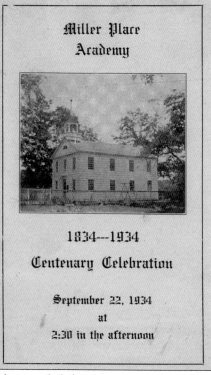

Miller Place Academy

1834---1934

Centenary Celebration

September 22, 1934

at

2:30 in the afternoon

On Saturday, September 22, 1934, one hundred people attended the centenary celebration of the Miller's Place Academy. Among the attendees were the oldest living person who attended the Academy, Corinne M. (Davis) Tooker of Port Jefferson (1847–1940), and the oldest male alumnus, Elihu S. Miller of Wading River (1848–1940). The day's program included refreshments, speakers, musical selections both vocal and instrumental, and "historic references." Rev. Frank Voorhees, minister of the Congregational Church, gave the invocation and Henry D. Silverman represented the Town of Brookhaven as a member of the board of trustees of the town. Though it had closed as a private school in 1868, the Academy remained a central part of the community. (Both images courtesy of Harry Randall.)

ERECTED AND OPENED AS AN EDUCATIONAL INSTITUTION IN

1834

Original Founders and Trustees

SAMUEL HOPKINS, President

CHARLES WOODHULL, Secretary and Treasurer

THOMAS HELME, Moderator

CHARLES MILLER

THOMAS STRONG

JOEL BROWN

1934

Present Trustees

SAMUEL H. MILLER, President

NATHANIEL TUTHILL, Treasurer

HEWLETT H. DAVIS, Secretary

CHAUNCEY W. DAVIS

ANNA H. DAVIS

—PROGRAM—

INVOCATION
Rev. Frank Voorhees

NATIONAL ANTHEM

WELCOME
Mr. Henry D. Silverman

ADDRESS BY THE PRESIDENT
Mr. Samuel H. Miller

VIOLIN SOLO
Mr. Louis R. Davis
Accompanied by Miss Isabel T. Davis

SUFFOLK COUNTY ACADEMIC FOUNDATIONS
Rev. Frank Voorhees

THE OLDEST LIVING MALE STUDENT
Mr. Elihu S. Miller

BARITONE SOLO
Mr. Alton Medagar
Accompanied by Miss Isabel T. Davis

REMINISCENCES
Mr. Chauncey W. Davis

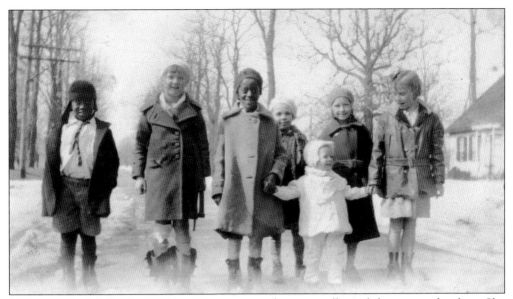

Margery (Martin) Davis would bring her camera along on walks with her young daughter. She took this photograph outside the Academy when it was being used as the public school, during the mid-1930s. Enjoying recess are, from left to right, Jim Smith, Jenny Kopcienski, Charlotte Smith, Gladys Ruckles, Jane Davis (infant), Anna Cherub, and unidentified. (Courtesy of Jane Davis Carter.)

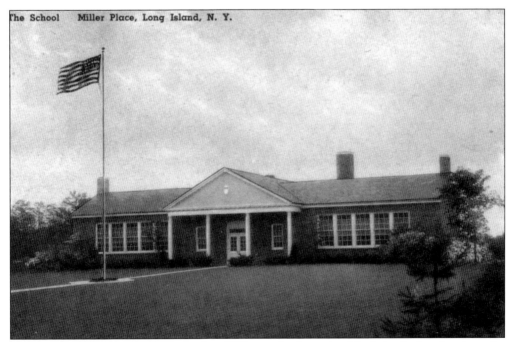

The Miller Place School, constructed in 1937, was the first school built in the hamlet since the 1800s. There were two classrooms, with four grades of students in each room. At the time, students in grades first through eighth attended. Since then, there have been many expansions, and today the building houses the North Country Road Middle School.

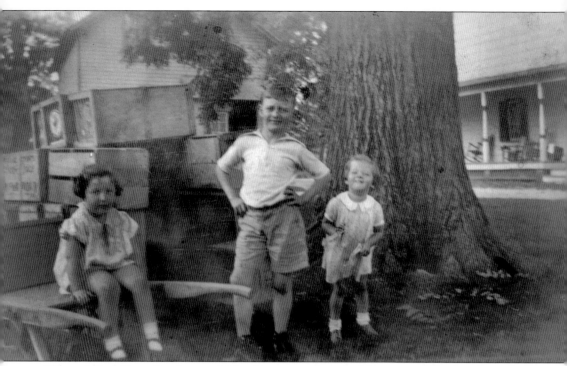

When Alfred Grant Davis was visiting his aunt and uncle, Margery and Hewlett Davis Jr., he built this house of orange crates. The crates came from his uncle's store, seen at the rear of the photo. The children are, from left to right, Mary Katherine Davis, sister of Alfred; Alfred Grant Davis; and Jane Davis, cousin of Alfred. (Courtesy of Jane Davis Carter.)

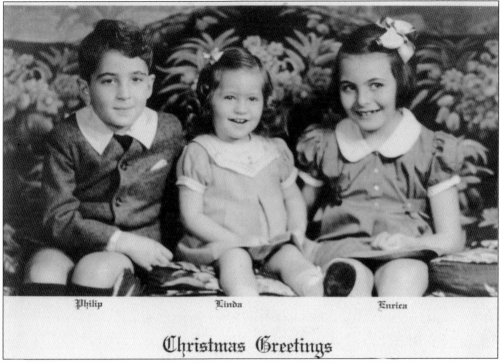

Philip Linda Enrica

Christmas Greetings

In 1926, Jean Fantoni Soma of New York City purchased the Ebenezer Miller house, known as the Ark during the Holiday House era. Her daughter, Enrica, married the actor John Huston; their daughter is actress Anjelica Huston. The Soma family spent many summers here. Although summer residents lived in Miller Place only part of the year, they remembered to send Christmas greetings to their friends in the hamlet (above). The Soma children are, from left to right, Philip, Linda, and Erica. During the summer season, the Soma children stayed with their nurses and played with the local children. Pictured below, from left to right, are Alvin Marelli, Robert Marelli, Enrica Soma, Jane Davis, and Philip Soma. In 1982, the Soma family sold the house. (Both images courtesy of Jane Davis Carter.)

Alilah Y. (Tillotson) and Samuel H. Miller celebrated their 50th wedding anniversary on September 18, 1928. Pictured here are, from left to right, (first row, seated on the ground) Samuel M. Tuthill, Isabel Tuthill; (second row, seated) Grace J. (Miller.) Tuthill, Samuel H. Miller, Alilah Y. (Tillotson) Miller, Alila M. (Miller) Tuthill; (third row, standing) Henry A. S. Tuthill, Irma Tuthill, Claude Tuthill, Anna Tuthill, and Nathaniel Tuthill. (Courtesy of Willis White.)

This hand-drawn map of Sylvan Lane shows property ownership north of North Country Road. Families already owned plots on the 10 subdivided acres, and Grace Chucouncilrch Boys Camp occupied the back area. Madelyn Serenbetz purchased 7.5 acres on the west side to build rental cottages. She bought surplus buildings and had them moved to the property and renovated by Ed Davis. George R. Serenbetz built their cottage near the rear of the property.

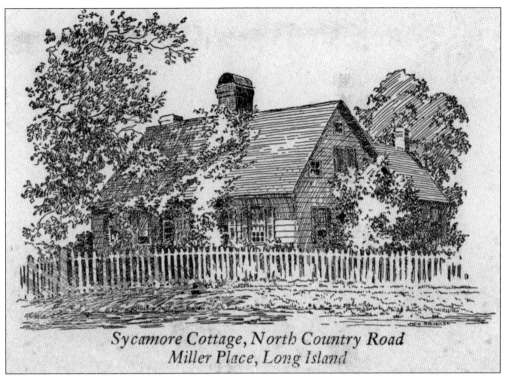

Sycamore Cottage, North Country Road
Miller Place, Long Island

This 1944 engraving shows the Timothy Miller House, built around 1785, the only typical Cape Code–style house in Miller Place. From the late 1800s until 1926, the family of the Reverend Morse Rowell owned the home and frequently rented it out during the summer. In 1936, Edward F. and Sally Field Stevens purchased the house for use as a full-time residence and named it Sycamore Cottage.

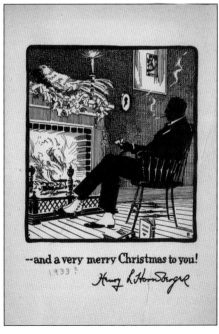

--and a very merry Christmas to you!
1933 ?
Henry L Hornberger

Henry L. Hornberger of Manhattan purchased the Timothy Miller house in 1928 and used it as a summer/vacation residence. In 1933, he sent this pen-and-ink drawing as a Christmas card to Samuel H. and Alilah Y. Miller. On Election Day, 1934, Hornberger's driver backed his car into the flagpole at the Academy. The pole fell through the roof of the car severely injuring Hornberger, who died shortly after.

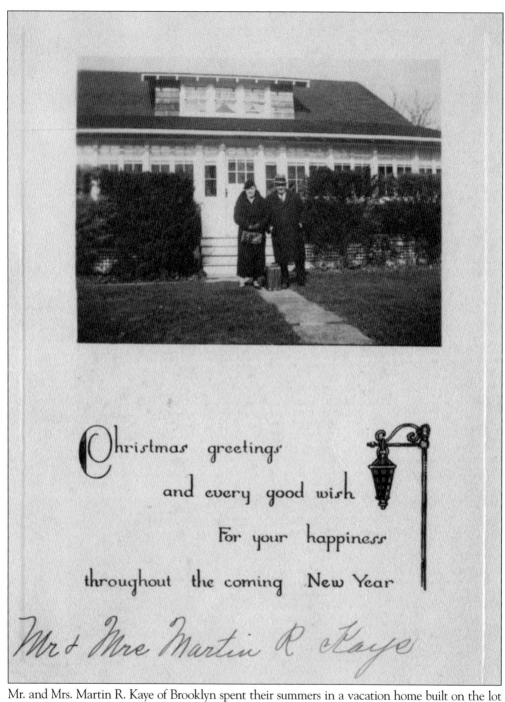

Christmas greetings
and every good wish
For your happiness
throughout the coming New Year

Mr & Mrs Martin R Kaye

Mr. and Mrs. Martin R. Kaye of Brooklyn spent their summers in a vacation home built on the lot they purchased just west of the William Miller house in 1921. In 1946, their daughter and her family became permanent residents of Miller Place until the house was sold out of the family in 1969. The Kayes showcased their summer home with a photograph on their Christmas greeting. (Courtesy of Helene Steffens Walker.)

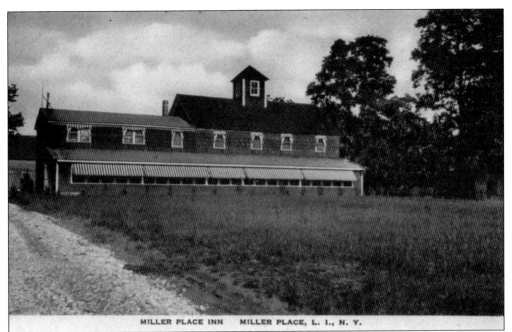

MILLER PLACE INN MILLER PLACE, L. I., N. Y.

In the late 1920s, Charles A Seifert combined the remaining barn and outbuildings on the Joseph R. Rowland property and built the Miller Place Inn (above). In June 1929, Louis C. Lang, manager, opened the inn, offering meals and accommodations. Miller Place was a rural retreat and the inn initially served hunters, preparing their freshly killed game. Matchbook covers, distributed free to patrons, were a popular and inexpensive form of advertising, beginning in the 1920s. Eye-catching designs spread the word about the inn from patron to future customers. This showgirl image (to the right) is one of the tamer designs used for the Miller Place Inn under the proprietorship of James Kapsalis. Today it has been rechristened as the Miller Place Inn and is in use as a catering hall, specializing in weddings. (Above photograph courtesy of Carol Gumbrecht.)

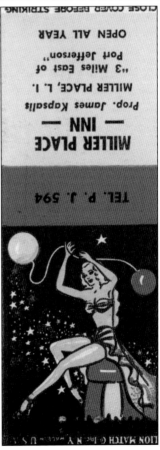

Alfred Beyer purchased the Woodhull house at 187 North Country Road on the corner of Lower Rocky Point Road in 1936. For three summers, he rented rooms in the large house to people on vacation from New York City. He christened the property the White House Rest and offered "excellent food and service" at "moderate prices." In the photograph (above), the porches are enclosed with screens, but today the porches are no longer screened in. Guests are relaxing on the side yard in 1938 (below). Vacationers could avail themselves of the various recreational activities available in Miller Place, including the beach, horseback riding, and bicycling riding. The door on the side visible in this photograph has now been replaced by a window. The roofs of three outbuildings are visible in the back. (Both images courtesy of Margaret Davis Gass.)

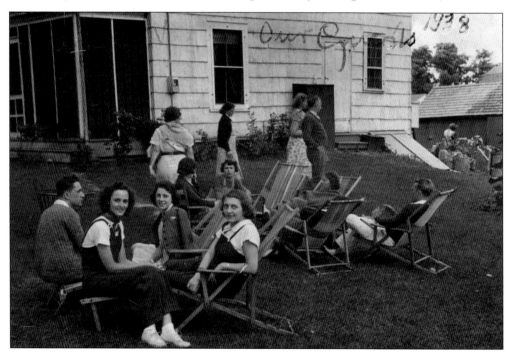

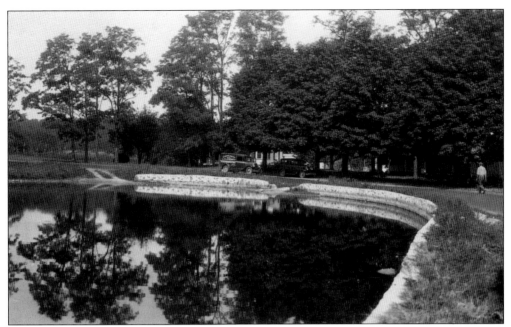

The Miller Place Pond was originally a stream running through swampland. Residents dammed the stream and dredged the area to create a pond in the 1600s. In colonial times, the pond provided water for crops and livestock and ice. Belle J. E. Rowell named the pond "Willow Lake" in her postcards. In the 20th century, the pond provided recreation including rowing, fishing, and ice skating. In later photographs (below) of the Miller Place Pond, the more substantial retaining wall is visible. The pond was still open for animals and also served vehicles in need of water to prevent overheating. Here a delivery truck from the Community Laundry of Port Jefferson is parked beside the pond. There have been several disputes over ownership of the pond with the town eventually claiming it as public property. (Courtesy of Jane Davis Carter.)

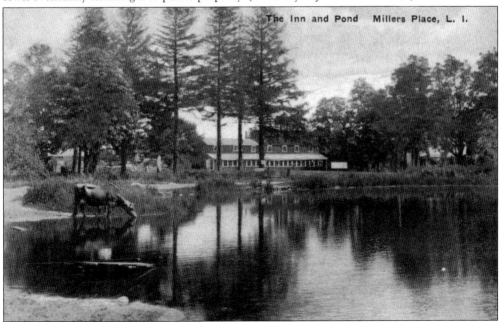

The Inn and Pond Millers Place, L. I.

Robert Burke holds Helene Steffens on the Miller Place beach as they enjoy ice cream in August 1935. The Miller Beach Surf Club was founded in the 1950s by summer community families. They purchased the former Tumbridge estate, including the main house, two cottages, several outbuildings, and a beach. (Courtesy of Helene Steffens Walker.)

Ready for a sleigh ride, John Ryder is holding Jane Davis on a small hill behind the pond. John Ryder had a farm across from the pond on the north side of the street, now 183 North Country Road. (Courtesy of Jane Davis Carter.)

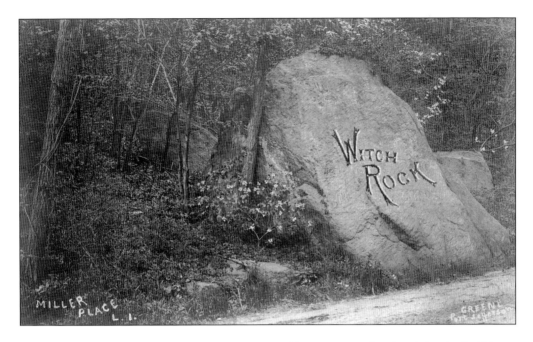

According to a February 3, 1933, article in the *Port Jefferson Times-Echo*, the 18-foot-high, 300-ton granite, glacial erratic rock on North Country Road, east of Pipe Stave Hollow Road, known as "Witch Rock" or the "Big Rock," was a well-known landmark (above). The paper suggests that in the post–Civil War period, "tramps" took shelter behind the rock, startling passersby and starting the legend of "Witch Rock." According to another story, pranksters used the rock to play tricks on young couples out on dates. In 1933, the rock was blown up to allow for widening of North Country Road. The Works Progress Administration (WPA) cleared the north side of North Country Road for widening (below). During the 1930s, the WPA sponsored projects throughout the nation to improve infrastructure, spur growth, and provide jobs for the unemployed. (Below photograph courtesy of Margaret Davis Gass.)

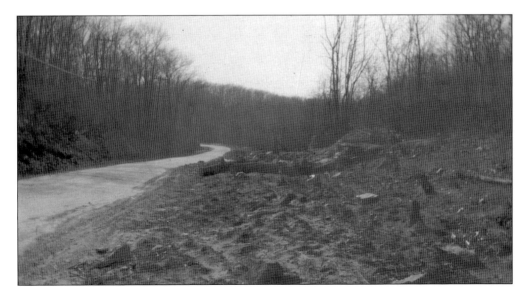

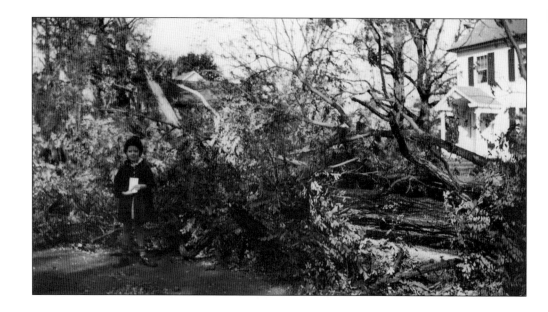

The hurricane of 1938 caused severe damage all over Long Island. On September 21, heavy rains and strong gusts toppled many of the locust trees that lined North Country Road. Jane Davis, later Carter, daughter of Hewlett Jr. and Margery Davis, stands near one of the many fallen trees in front of her parents' house at 131 North Country Road (above). At 125 North Country Road, Bert Smith checks out one of the locust trees that fell on the Hewlett H. Davis Store (below). The metal barrel behind the building contains kerosene which people would purchase to fuel cooking or heating stoves. New Deal administrations sent workers and funds as part of disaster relief—a federal effort unusual at its time. (Both images courtesy of Jane Davis Carter.)

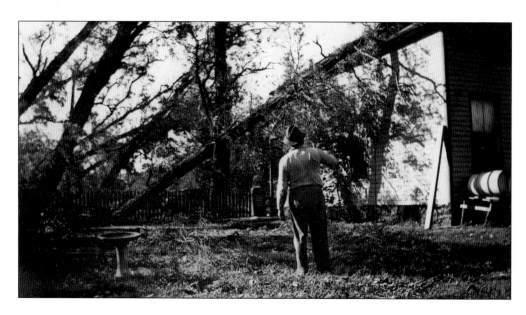

Four

COMMUTER COMMUNITY
1940–1980

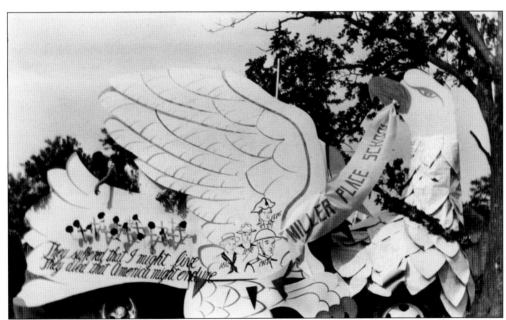

In 1940, Miller Place School entered a float in the annual Memorial Day parade. Andrew Crowell designed the float, with line drawings of soldiers from the Revolution, the War of 1812, the Spanish–American War of 1898, and World War I. John Ryder loaned one of his farm trucks, driven by Bert Smith. The children and teachers of the lower grades rode on the float. (Courtesy of Jane Davis Carter.)

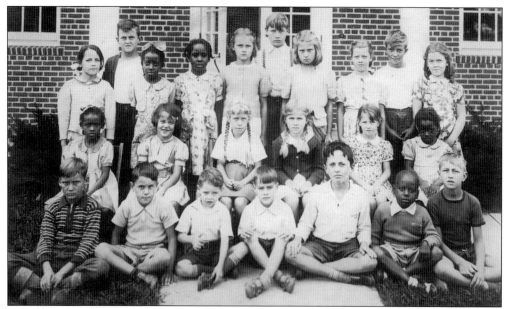

This school photograph from 1940, taken at the front entrance, shows students in grades one through four. The students are, from left to right, (first row) Denos Marvin, Raymond Geoghan, Nelson Hall, John Engle, Peter Plate, Edward Vaughn, John Kopcienski; (second row) Doris Epps, Marjorie Plate, Tookie Pooler, Helen Hocker, June Hall, Mary Smith; (third row) Elaine Marvin, Alfred Geoghan, Irene Vaughn, Catherine Smith, Ardeth Crowell, John Bahr, Frances Bayles, Jane Davis, Ronald Paradis, and Eileen Calace. (Courtesy of Jane Davis Carter.)

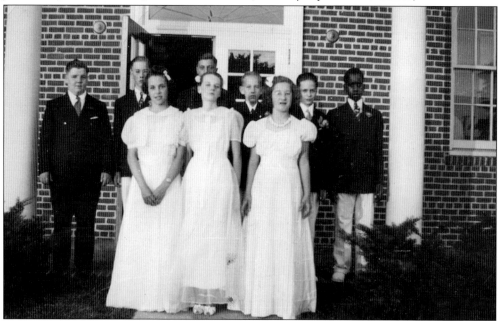

At the 1940 eighth-grade graduation ceremony, boys wore their best suits, and girls wore formal gowns. In this photograph taken at the front entrance, the boys are, from left to right, Charles Calace, Charles Rulau, Patsy Ruffini, John Dalton, Rodney Roeber, James Smith; the girls are, from left to right, Gladys Ruckels, Evelyn Hall, and Anna Cherub. (Courtesy of Jane Davis Carter.)

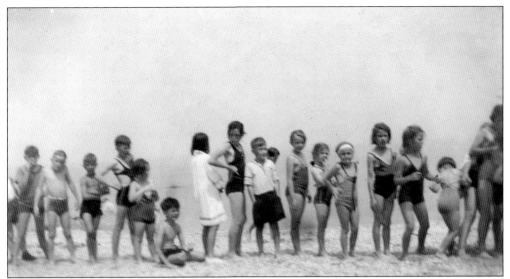

To celebrate the end of the school year, the children had an annual picnic at the beach. Students walked from the school to the beach at the end of Nathaniel Davis's Cordwood Road, now Cordwood Landing County Park. Activities included games, swimming, and a picnic lunch. This photograph, taken in the 1940s, shows students waiting in the ice cream line. (Courtesy of Jane Davis Carter.)

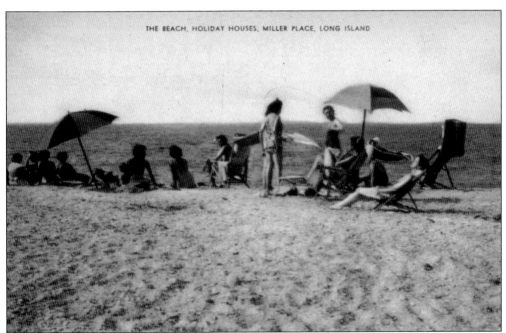

THE BEACH, HOLIDAY HOUSES, MILLER PLACE, LONG ISLAND

By the 1940s, going to the beach had become more of a social outing. Swimming and sunbathing gained in popularity with the young women staying at the Holiday House Beach. Bathing suits were designed for swimming, allowing for greater freedom of movement than before. Larger umbrellas provided space for more than one person to seek shade. Lounge chairs allowed bathers to relax comfortably above the sand.

Dorothy Hopkins was born in Brooklyn but traveled frequently to Miller Place to visit her grandparents, Samuel J. and Sarah C. (Hallock) Hopkins. Dorothy became a registered nurse and met her future husband, Dr. Ainsworth Smith (seen below), while they both worked in Brooklyn Hospital. They purchased the Jonathan Marshall house from her father, Philip Hopkins, to use as a summer/vacation retreat. When Dr. Smith retired, the couple moved permanently to their Miller Place home and increased their involvement in community activities. The couple collaborated with Merrill and Marianne Brown to found the Miller Place Historical Society. Dr. Smith and Mr. Brown also worked to establish the Historic District Ordinance in the Town of Brookhaven and the designation of North Country Road in Miller Place as the first historic district in the town of Brookhaven. (Both photographs courtesy of Jacqueline Smith Flourney.)

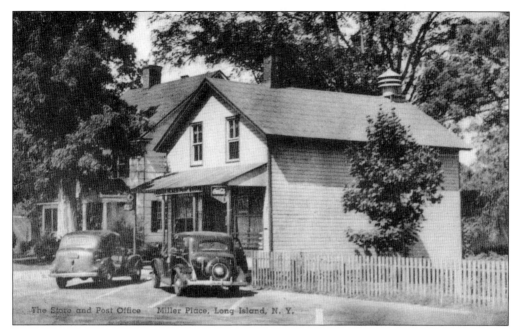

The Store and Post Office Miller Place, Long Island, N. Y.

During World War II, Hewlett H. Davis served as an air raid warden. Davis or a designated surrogate had to be available at all times to sound the alert using the rooftop siren on top of his store during drills or in case of enemy attack (above). Davis's daughter Jane, age 10 in 1942, sounded the alarm for a drill when both parents were unavailable. When the siren's services were no longer needed, Davis removed it in 1947 (below). Charles T. Davis, his cousin, and an electrician completed the work. Charles is shown pulling on the electrical cable that had run from inside the building to the siren. Miller Place did not have a fire department at this time so the small truck most likely belonged to the Mount Sinai Fire Department. The reason for the fire truck's presence is unknown. (Courtesy of Jane Davis Carter.)

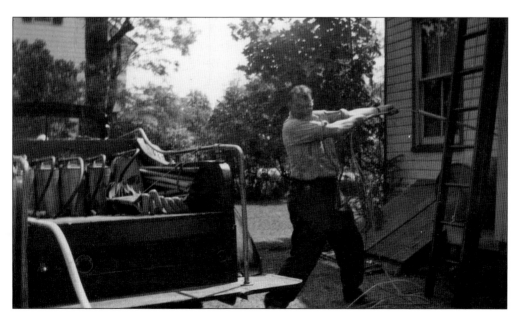

Melville Warner's potato barn, also known as a potato cellar, was located south of the pond and west of North Country Road. Such structures were common at a time when Long Island was one of the largest potato-growing regions in the country. Banking the buildings with dirt provided a consistent cool temperature for the storage of potatoes. The doors in the peak at either end were opened in the evening, allowing warm air to be released. Potatoes were later taken to market in bulk or bagged. (Courtesy of Margaret Davis Gass.)

After one of the snowstorms in 1950, the Steffens family hitched Helene's horse, Cadet, to a sleigh borrowed from a neighbor. Unfortunately the snow did not last long enough for a very long ride through the village. Jean Brennis holds her daughter, Kris, while Helene stands next to the sleigh (above). (Courtesy of Helene Steffens Walker.)

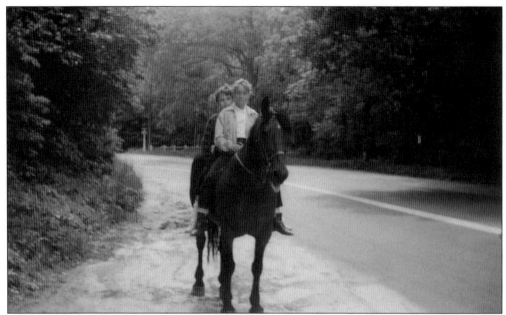

Carol Korinek and her friend, Barbara Grossman, ride Carol's horse, Pride, bareback on North Country Road during the 1950s. Horseback riding and owning horses was common in Miller Place, even with the replacement of horses by the automobile. Most riders were young, particularly girls. There were many fields, old dirt roads, and trails available for riding. It was also possible to ride on the main roads, because there was little traffic. (Courtesy of Frances Korinek Iwanicki.)

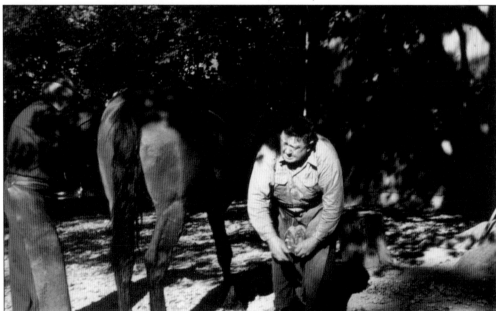

Mr. Conklin was a farrier who traveled with his portable shop. Farriers provided the periodic maintenance horses required, including shoe replacement and hoof trimmings. In years past, the farrier could also serve as a blacksmith. The advent of trucks and trailers allowed farriers to bring their services on the road. Mr. Conklin's residential address is unknown, but he visited Miller Place to shoe for the Korinek horses. (Courtesy of Frances Korinek Iwanicki.)

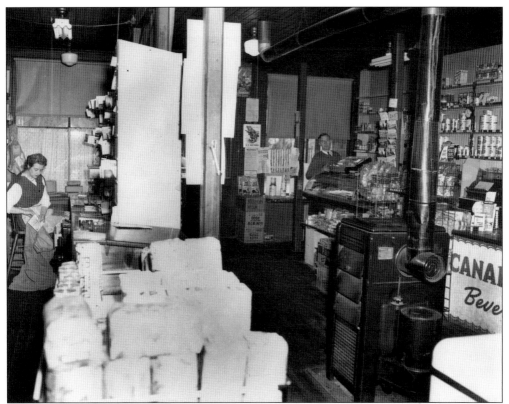

Hewllett H. and Margery (Martin) Davis are shown here in their post office–general store at 125 North Country Road (above). Marjory is sorting through recently delivered bags of mail, preparing to put letters in the mailboxes rented by many of the residents. Newspapers stand at the end of the postal boxes. Hewlett is busy stocking the shelves in the store. Products available in the general store in the early 1950s, many of which are still available today, are on display (below). This store made it convenient for the many residents without a car to shop for needed supplies. The large metal box in the center of the store is the source of heat for the building. When the waiting list for postal boxes grew to over 200 in 1955, Davis closed the general store side and turned it over to the post office.

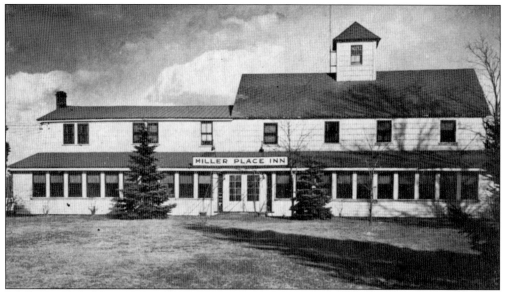

The Miller Place Inn continued to expand its restaurant and catering business while room rental became less popular. By the 1950s, James Kapsalis took over as the inn's proprietor. Hunting, still widely practiced in the area with its open fields and woodland areas, provided plentiful game for the table.

Vacationers post–World War II preferred rental cottages over large inns. The two cottages at the Miller Beach Surf Club were rented out each summer. Arthur Miller spent several summers in the Miller Place and Mount Sinai areas, renting one of these cottages in the 1940s. Paul Newman rented one of the cottages while he was performing in a Broadway show in 1953 and spent time on the beach with his daughters.

In the late 1950s, the Daniel R. Miller house was converted to a restaurant known as the Secret Road Inn (above). A popular gathering place, the Secret Road Inn was one of the few area restaurants to serve French cuisine. Since the rooms used for dining were small, patrons had to wait to be seated. Elaine and Wesley Hoffman owned and operated the restaurant from 1963 to 1967, when Guy L'Heureux became proprietor. After L'Heureux sold it in 1980, the new owner expanded the restaurant to its present size. Currently known as Brian Scotts, the restaurant has had four names and food specialties over the last three decades. A. Twitchell painted the menu cover seen to the right. This painting was also used for the holiday advertisement for the Secret Road Inn in a December 1958 issue of *The Record*.

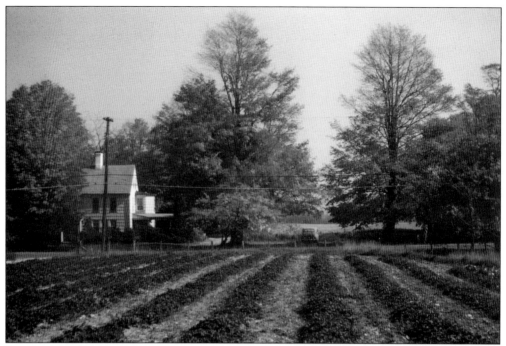

Despite their short growing period, strawberries are a popular fruit on Long Island. Melville Warner had rows of strawberries on his field facing North Country Road, south of the pond and across from the Horace Hudson house. Most strawberries were picked by hired labor and either sold at local stands or sent to New York City. (Courtesy of Frances Korinek Iwanicki.)

Chauncey Davis built this glass greenhouse sometime before 1935. This photograph dates from the early 1950s and shows the building still actively in use and level with the road. Today the building is boarded over, and the road has been paved several times, bringing the building below grade. (Courtesy of Frances Korinek Iwanicki.)

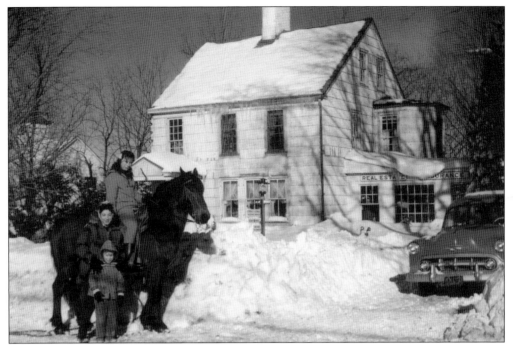

In the 1950s and 1960s, snowstorms were not uncommon on Long Island. Kathy Korineck was still able to ride her horse in the cold weather. She is shown here mounted on her horse, Pride. Standing next to her is a friend and neighbor, Mary Nania, and Kathy's cousin, Peter Demopoulos. (Courtesy of Frances Korinek Iwanicki.)

As soon as the ice was thick enough, residents of all ages spent hours skating at the Miller Place Pond. This 1955 scene is reminiscent of earlier generations of skaters. The skaters in the front are, from left to right, Sniffles the dog, Kathy Korinek, Teddy Demopoulos, and Carol Korinek. (Courtesy of Frances Korinek Iwanicki.)

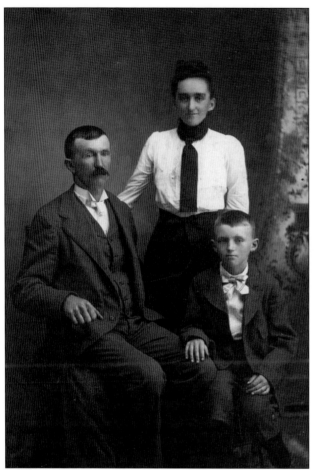

Cornelius H. Helme, son of Timothy H. and Susan (Hopkins) Helme, married his cousin, Maria Sweet Helme, the adopted daughter of George P. and Hannah (Burnell) Helme. They lived in the ancestral Thomas Helme house with their son, George P. Helme. Cornelius remarried and moved to Terryville after Maria died in 1903, and the house was rented. As an adult, George P. Helme married a Miller Place neighbor, Marion Davis, daughter of Nathaniel T. and Marianna (Davies) Davis. They returned to the Helme house until he passed away in 1950, and she passed in 1957. After her death, Arthur Lambert of New York City, a member of the Pied Pipers, a Big Band–era singing group, purchased the house. Lambert used the house as a summerhouse until he retired and moved to Miller Place permanently. After Lambert's death in 2001, the present owner bought the house. (Both photographs courtesy of Margaret Davis Gass.)

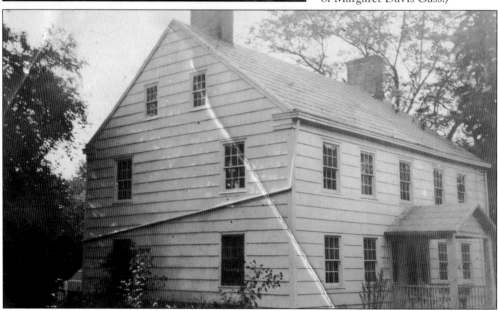

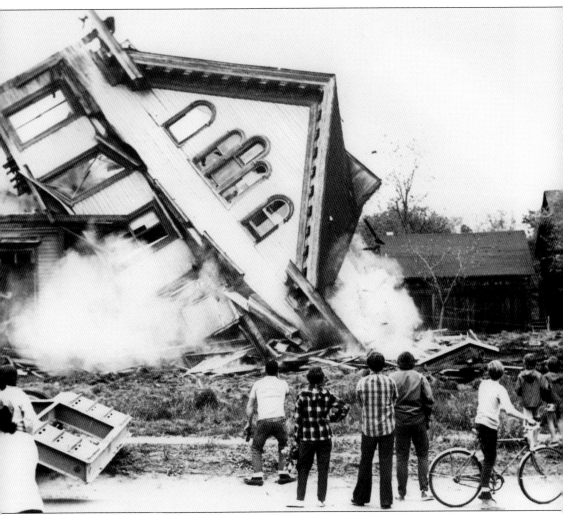

The Working Girls Association sold the Holiday House property to the Nassau Country Girl Scouts Council for expansion of Camp Francois Barstow. Despite interest in the preservation of the once beautiful home in the heart of the hamlet, no plans or resources materialized. Vandalism gradually took its toll on the property; in 1970, workers bulldozed the house. In the 1980s, Suffolk County purchased the entire Camp Barstow property, now Cordwood Landing County Park.

The Girl Scouts have been a part of the Miller Place community since before World War II. In the 1970s, Helen Hocker Samuels led Troop 760. The Scouts participated in many activities. In this photograph, Diane and Nancy Jordan display their Apple Head Dolls, which they crafted for a contest. They won second prize. (Courtesy of Helen Hocker Samuels.)

The Girl Scouts have marched in parades for many years, including the Rocky Point St. Patrick's Day parade and the Port Jefferson Fourth of July parade. Helen Hocker Samuels marches with her Troop 760 in the Fourth of July Port Jefferson Parade in 1972. The Girl Scouts are passing Cooper's stationery store, which was on Main Street. The reviewing stand was on West Broadway. (Courtesy of Helen Hocker Samuels.)

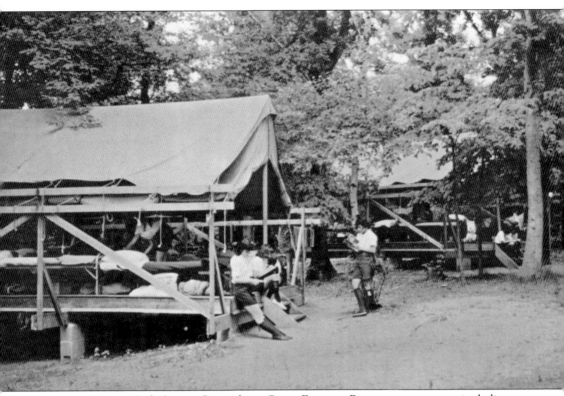

The Nassau County Girls Scouts Council ran Camp Francois Barstow on property, including a beachfront, purchased in 1947 from Hewlett H. Davis Jr. and his three siblings. Tent platforms were erected for the large tents. Troops spent one to two weeks on site hiking, swimming, and cooking in open pits. The council's plans to expand the camp were opposed by neighbors. In the 1980s, Suffolk County purchased the property and transformed it into Cordwood County Park.

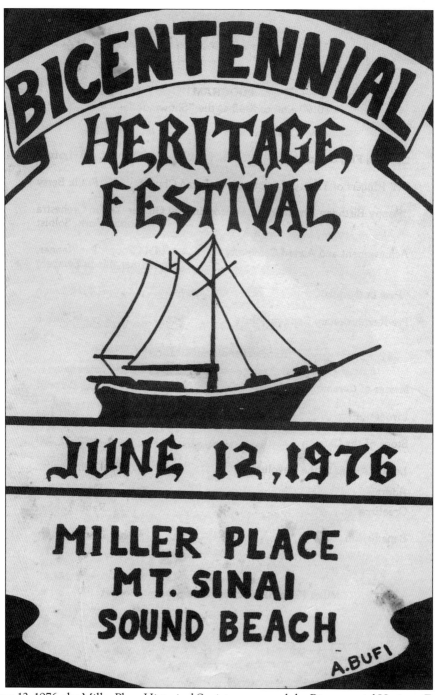

On June 12, 1976, the Miller Place Historical Society sponsored the Bicentennial Heritage Festival. Many local organizations participated in the all-day celebration, which included displays, exhibits, games, encampments, arts and crafts, musical exhibitions, and many other activities concerning the history of Miller Place. The civic association, the chamber of commerce, the Boy and Girl Scouts, school groups, living history groups, and individuals from Miller Place, Mount Sinai, and other surrounding communities contributed to the event's success.

Helen Hocker Samuels and John Gass wait on John and Margaret Gass's lawn for the bicentennial parade to start. They were among the founding members of the Miller Place Historical Society and were active in community organizations. The parade started at the Old Rocky Point Road and traveled along North Country Road to Honey Lane. Helen grew up in Miller Place and John, originally from Farmingdale, married Margaret Davis, a local resident. (Courtesy of Helen Hocker Samuels.)

Jennifer Bohack, age six, and Amber Bohack, age four, were some of the children who participated in the Bicentennial Heritage Festival. Here they are dressed in period costume as part of one of the groups marching in the parade. One of the many relatives or friends who lined the parade route took this photograph.

Five

CIVIC PRIDE
1980–2010

Kelly Harkins was a longtime resident and caretaker of the Miller Place Pond, as well as a cheerful presence and beloved neighborhood figure. Despite her physical disabilities, she was an active community member—working in the schools and assisting in landscaping and cleanup of the pond. A plaque recognizing her contributions was officially installed on a rock at the pond during a dedication ceremony in 1999. (Courtesy of Mindy Kronenberg.)

Brian Scotts American Restaurant is the newest in a long line of neighborhood restaurants, stretching back 50 years, serving the community at the former Daniel R. Miller house. The menu is American eclectic. Previous establishments have featured French, Irish, and Italian cuisines. Catering facilities on the premises serve local residents and businesses.

A popular stop for locals and those passing through the North Shore on North Country Road, The Town and Country Market offers hot and cold meals throughout the day and stocks a small selection of groceries and home supplies. The store exists on property originally sold by Harry Millard in the 1950s. The new owners have renovated the building and have been open for the past year.

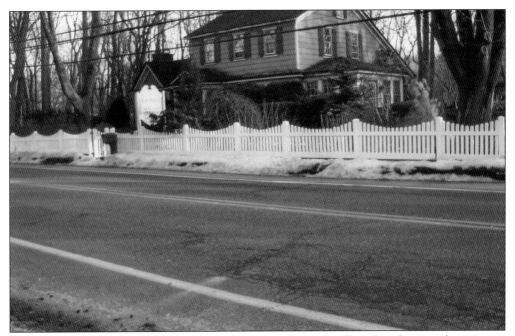

The Erastus Brown house was converted from a private home to offices for John Ray's law practice in 1986, active at this location to the present time. During the Christmas holiday, a festive sign replaces the original and reads, "The Offices of Scrooge and Marley."

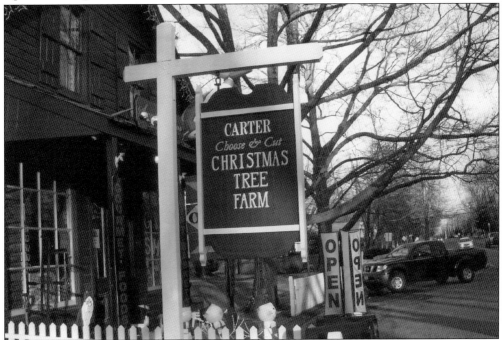

Ann Carter established the Christmas Tree Farm in 1984 and continues to own and operate in this location, 5 acres north of North Country Road. Locals and residents from across Long Island buy their Christmas trees in a continuation of a farming tradition on the property started by her ancestor, Capt. Alfred M. Davis.

Fran and Al Morbillo moved their confections business, Sweet Creations Candy Shop, into this historic property in 2008. The building is owned by Jane Davis Carter, descendent of Hewlett Hawkins Davis. Over the years, this former general store and post office has housed a series of shops selling a variety of goods including antiques, candles, and crafts.

In 1992, Gail and Jim McNulty opened McNulty's Ice Cream Parlor. The shop was originally built in the early 1950s. A tackle store, luncheonettes, a bookstore, and a sporting goods store have occupied the space. McNulty's has become a hub for community activity and a gathering place for families.

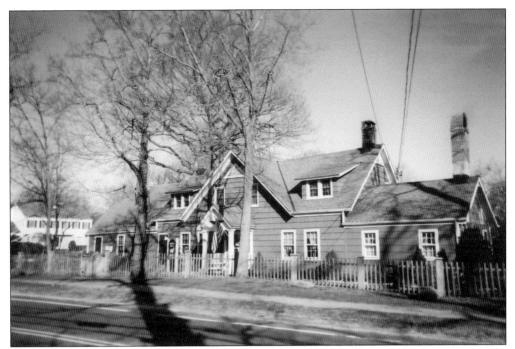

Bob and Lorraine Opitz opened the Miller Place Ark, a bed and breakfast, in 1995. Housed in the Ebenezer Miller House, the Ark has three guest suites, two of which are named for ancestors of Ebenezer Miller. This name, the Ark, recalls the time when the house served as a boardinghouse for the overflow of residents at the Holiday House.

The Miller Place Post Office opened on December 7, 1990, as a new facility specifically commissioned for the postal service. It succeeded the building on the south side of Echo Avenue, which had served as the post office from 1970 to 1990. Carrying on a tradition that started in the Thomas Helme house in 1825, this facility has been able to accommodate the growing post office boxes and home delivery needs of the Miller Place hamlet.

The firehouse was completed in 1954 and expanded in 1989 to accommodate a greater number of larger trucks. The expansion included adding rooms for community meetings and offices. At the time the firehouse was built, its location on Miller Place Road made it easily accessible for members of the department. Over the years, the fire department has expanded to meet the needs of the growing district. It has included not only trucks but marine and emergency medical vehicles. With the growth of commercial buildings and decline of farming, there has been a change in the types of fires fought by the department. In 2006, the fire department annex was opened on Miller Place Road, south of State Route 25A, to meet the needs of the growing development in the southern part of the community.

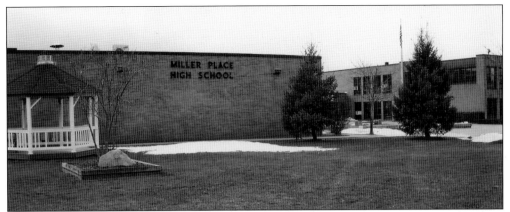

The first class of Miller Place High School graduated in 1975. Before the completion of the building, students were transported to Port Jefferson High School, now known as Earl L. Vandermeulen High School. The school is used by the community for a variety of civic events. All grade levels, from kindergarten through grade 12, are provided within the Miller Place District.

Volunteers established the North Shore Youth Council in 1982 to provide free comprehensive youth and family services to area residents. This drawing of milk cans and a pail by a child in the North Shore Youth Council was part of a coloring book presenting the history of the 1720 William Miller House. The coloring book was published by the Miller Place–Mount Sinai Historical Society, with a grant from Mark Alessi of the New York State Assembly.

The Larsen family is seen here participating in the Keep Brookhaven Beautiful/Civic Spring cleanup of Echo Avenue on April 11, 2008. The Miller Place Civic Association sponsors yearly cleanups, beautification efforts at a number of local sites, and keeps an eye on zoning for new construction and architectural integrity as well as appropriate landscaping on public properties. (Courtesy of Kathy Rousseau.)

Roberta Goldberg (left) and Pam Zaiontz (right) join in the Keep Brookhaven Beautiful Plant-In of May 2008. Over the years, Miller Place Civic Association beautification projects have included the planting of maple trees along Echo Avenue and landscaping at the Miller Place Pond. They have encouraged other community groups to support these efforts. (Courtesy of Kathy Rousseau.)

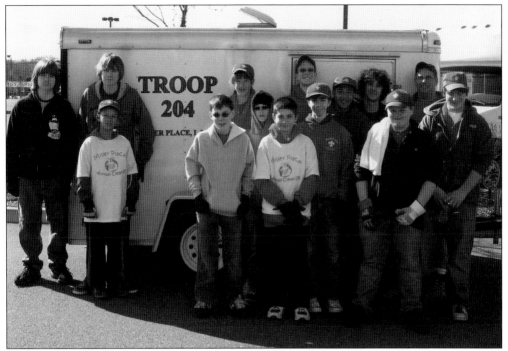

The Miller Place Civic Association serves as charter sponsors to Boy Scout Troop 204 and Cub Scout Pack 204, seen here preparing for the annual spring cleanup of 2007. The Civic Association has always been dedicated to youth activities. In the 1980s, it supported the tri-district council, the predecessor of the North Shore Youth Council. (Courtesy of Kathy Rousseau.)

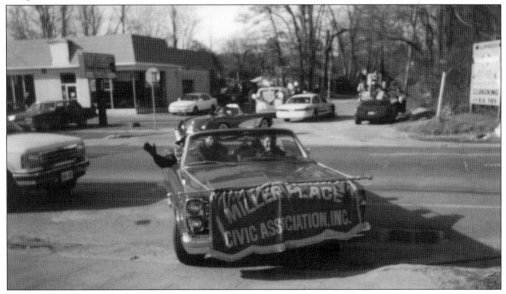

The Miller Place Civic Association is featured prominently in many local festivities, including the St. Patrick's Day Parade. This celebration includes a procession of vehicles and floats, beginning in Miller Place and ending in downtown Rocky Point. Here members of the Civic Association conclude their 3-mile ride in a vintage car in the parade of 1997. The 60th year of the parade was in 2010, sponsored by the Friends of St. Patrick. (Courtesy of Antoinette Donato.)

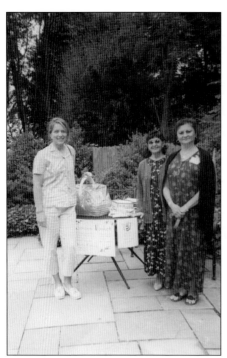

The first Garden Tour of 2003, which attracted 70 participants and culminated in a tea at Point Place (the Samuel Hopkins House), was a new event sponsored by the Historical Society. The tour included unique gardens from five local homes and ended with a repast of finger foods and home-baked goods. Pictured are, from left to right, Paula DeFilippo, Antoinette Rodriguez-Eden, and Antoinette Donato. (Courtesy of Antoinette Donato.)

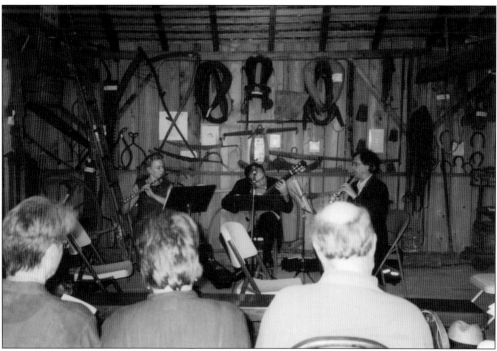

The Constellation Trio performs chamber music in a 2003 summer concert inside the Cherub Barn, sponsored by the Greater Port Jefferson–Northern Brookhaven Arts Council. The program included works by Mozart, Stravinsky, and Bach, played on the oboe, flute, and guitar. Following the concert, guests enjoyed refreshments and mingled with members of the society and the musicians on the bucolic lawn behind the William Miller House. (Courtesy of Mindy Kronenberg.)

Capt. Thomas Terry of the Suffolk Provincial Militia, as portrayed by James Downey (seated), made a yearly visit to the Miller house in the early 2000s. He is shown being served by one of the camp followers. This particular encampment was a reenactment of the militia's actual stopover in Miller Place during the French and Indian War when the William Miller House was commandeered in the name of the king. (Courtesy of Mindy Kronenberg.)

Designed and sewn by local women, each of whom signed the quilt, the squares of the Miller Place Bicentennial Quilt depict several historic buildings and scenes of Miller Place. The design includes the seals of the Town of Brookhaven, Suffolk County, and the State of New York, as well as the Liberty Bell, the eagle, and the symbol of the bicentennial.

In 2005 and 2006, the society sponsored an all-day antique fair, which brought in dealers from Port Jefferson and across Long Island. Visitors browsed through glassware, pottery, furniture, sports equipment, and artwork and could take a tour with a docent throughout the William Miller House. Brochures were also available for patrons to take self-guided walking tours of the historic district. (Courtesy of Mindy Kronenberg.)

In June 2008, the Long Island Street Rod Association generously shared its vintage automobiles, which included custom cars, street rods, hot rods, and muscle cars. Each of the owners answered questions and discussed details of his own cars. The event was supported with the help of many local merchants who contributed raffles. Once again, tours of the William Miller House were provided. (Courtesy of Mindy Kronenberg.)

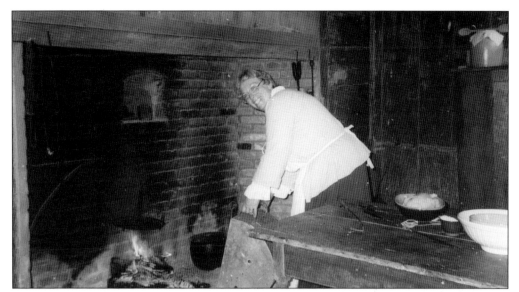

The country fair has been the major event of the Historical Society, providing demonstrations of various crafts and skills. Open-hearth cooking always proves to be popular, allowing visitors to observe colonial cooking methods, such as roasting chicken, baking bread, and making stews, and learn about the utensils used in meal preparation. Cooks also share history and folktales connected to food. Edna Davis Giffen is maneuvering a tin oven for roasting a chicken. (Courtesy of Mindy Kronenberg.)

Handicrafts are among the most popular demonstrations. Here Katherine "Kit" Davis is making a decorative hooked rug out of wool, using a portable wooden frame to keep the material taut. Her son, Michael, chats with his mother during a break. Davis was a member of the Smithtown Stitchers, a group that practices the art of making domestic goods, such as quilts and rugs. (Courtesy of Mindy Kronenberg.)

Paula DeFilippo demonstrates the use of the spinning wheel for country fair participants. She is pictured with a sample of spun flax that would have been used in the colonial era to make linen for clothing and household cloth. Spinning was necessary to provide material for weaving and was the last of many steps involved of turning flax into linen thread. (Courtesy of Mindy Kronenberg.)

Mary Dibble demonstrates the art of basket weaving. Baskets of all sizes and designs were used for a variety of purposes, much in the way that we use boxes, bags, and pails. Dibble wove baskets as she spoke about the materials and techniques used in their construction and how each shape reflected function or whimsy. (Courtesy of Mindy Kronenberg.)

Deanna Nelson waits for the next group of visitors. Arranged on the table are a series of tools used to transform cotton, wool, and flax into cloth. On her right is a portable loom, for weaving cloth for small items, such as caps or strips that were sewn together to make sheets. Most professional weavers in colonial times and earlier were men. In the 1600s, the Town of Brookhaven hired Joseph Davis to be the town weaver. (Courtesy of Mindy Kronenberg.)

Nate Gass takes a break from stilt walking, a form of amusement for colonial children. To the right of the photograph, a group of youngsters are painting clay decorative ornaments made earlier in the day by Candy Scott, a professional potter. On the left, boys are admiring a vintage farm tractor owned by John Randall. (Courtesy of Barbara Bennett.)

119

In previous years, when the country fair was held in August, Harry Randall demonstrated sheep shearing on his own flock, transported to the Miller House from his farm. Sheep were commonly kept on Long Island farms into the 20th century. In the 1600s, specific areas of town were designated for grazing, known as the Sheep Pasture Lots. Sheep are typically sheared in the spring, to cool them in the summer and allow them to re-grow their coat to protect them in the winter. The sheep pictured from this past September's country fair reveal partially grown coats.

Harry Randall engages visitors with a discussion of the numerous farm tools contained within the barn. Over the years, he has collected an extensive variety of these tools from many of the farms in Mount Sinai and Miller Place. A small example includes scythes, grain cradles, milking machines, animal harnesses, and a circular saw for a steam-powered sawmill. (Courtesy of Barbara Bennett.)

Outside the Chereb Barn, Matt Kopcienski watches as his two youngest children, Sam and Margaret Ann, inspect the wooden cow, made by Richard Gass. The cow, popular with young visitors, is fitted with an apparatus for "milking," teaching children about chores connected to farm life. Although the larger farms, such as Randall Farms, became automated, people with single cows continued to milk by hand. (Courtesy of Barbara Bennett.)

Members of the 30th Virginia Civil War Living History Group relax and converse with visitors at the 2009 country fair. The group demonstrates cooking, camp life, and drills that are authentic for the time of the Civil War. Their tents are open for viewing, and visitors are encouraged to ask questions. All group members are local residents. (Courtesy of Barbara Bennett.)

Farmers required many tools to maintain their equipment. The walls of the Chereb Barn are covered with many of the tools used during the era of the horse. This is the rear wall of the barn showing harness, a saddle, yokes of various sizes, scales, milk cans, bottles, sleigh bells, and cowbells. The bag at the left is from the Prechtl Farm, the last potato farm to close in Mount Sinai. (Courtesy of Mindy Kronenberg.)

In 2008, Ethel Lee-Miller published a book on the summers she spent in Miller Place. Like so many other families from the New York City area, her family had purchased property near the beach in a rural community. At the country fair she held a book signing. Here she is pictured standing with Edna Davis Giffen on her right and Ann Donato on her left.

Helen's Attic Shop, selling decorative household items, objets d'art, and antiques, is adjacent to the William Miller House and run by Helen Samuels. The shop is open on Saturday mornings from April to October. At the country fair, all items donated throughout the season are brought out and displayed for sale. The Attic Shop has been a fixture on the property for over 20 years and has assisted in raising funds for the society. (Courtesy of Barbara Bennett.)

The blacksmith was known for his skills in forging iron for the creation of kitchen implements and tools for the house and farm. He played an important part of the community, where most household items were fashioned from iron and steel. Many blacksmiths also served as farriers, shoeing horses as a sideline. A large part of their business involved repairing pots, cooking utensils, and farm implements. Here a blacksmith is preparing his tools for a demonstration at the country fair. Children can participate by assisting in making an S hook, which held suspended cooking pots or other common items in the house or barn. (Courtesy of Barbara Bennett.)

Starting in the early 1980s, a celebration of the holiday season was held at one of the historic homes. For many years, it was held at Point Place during the Christmas season. Bob Arnold opened his beautiful home to the members of the society and the general public. For several years, the celebration became a Twelfth Night affair and was hosted by Art Lambert and Kirkland Grant. This photograph is of guests at Kirkland Grant's Davis Island home.

On the first Sunday in December, children come to the post office on the William Miller House property to mail letters to Santa. Postman Pete accepts their letters, stamps them, and places them in a bag for delivery to the North Pole. Within a week, the children receive a reply from Santa. Pictured are, from left to right, Antoinette Donato (chairman of the Postman Pete event), Lianna Kosch, Elizabeth DeLio, and Peter Mott—Postman Pete.

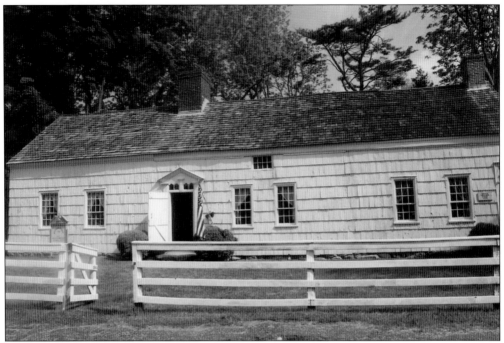

In 1979, the Miller Place Historical Society purchased the William Miller House from the estate of Harry Millard. The main restoration effort occurred in the 1980s, and the house remains the focal point of society events. Through the generous donations of community members, the society has been able to add buildings to the property. These historically significant structures are used for various events to showcase the history of Miller Place and Mount Sinai.

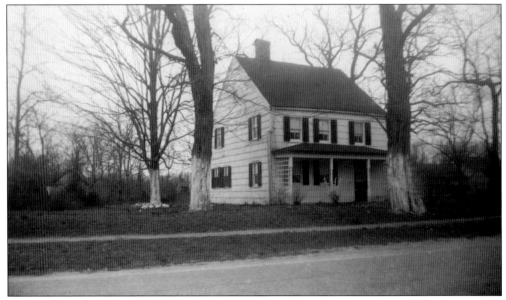

Arthur and Linda Calace donated the Daniel Hawkins House to the society in 1995. The Miller Place–Mount Sinai Historical Society is restoring and renovating the house to provide a place for its archival collections and meeting rooms for a variety of historical activities. Meetings and archival research will be available for all members of the community.

ABOUT THE MILLER PLACE–MOUNT SINAI HISTORICAL SOCIETY

The Miller Place Historical Society was established in 1974 to collect, preserve, and share the history of New York State with an emphasis on Miller Place and surrounding areas. In 1984, the name was changed to Miller Place–Mount Sinai Historical Society to recognize involvement from members of neighboring Mount Sinai and reflect the expanded collections.

Purchasing and preserving the 1720 William Miller House in 1979 provided the Society with an initial focus and a hub for events. The addition of the 1810 Daniel Hawkins House in 1995 continues to provide additional opportunities for restoration and preservation of a historic property.

The Historical Society's collections include photographs, paper ephemera, farm tools, and other objects that have specific connections to Miller Place or Mount Sinai. Information obtained from the collections provides insight into the lives of the people who resided and worked in the communities.

An active custodian of the community's heritage, the Historical Society provides many enjoyable opportunities for residents and visitors to learn throughout the year. Volunteers lead tours of the William Miller House from June to September on Saturdays and by appointment. Guest speakers at Society meetings offer insights on various aspects of Long Island and New York State history. The country fair in September is a veritable cornucopia of local traditions, customs, and history, including crafts, demonstrations, and reenactments. In June, the fourth grade of Mt. Sinai Elementary School makes an annual trip to the William Miller House where the students have guided tours of the William Miller House, the Chereb Barn, and the Miller Place Historic District. The Web site has a page with updated information on local history.

The Historical Society has published a number of pamphlets for people interested in learning more about the community's past. "Walking Tour" brochures for the historic districts of Miller Place and Mount Sinai provide residents and visitors alike with a glimpse into the region's rich history. Children enjoy finding and learning about items of interest with *A Scavenger Hunt of the Miller Place Historic District, the William Miller House,* and *the Chereb Barn.*

The Historical Society is a non-profit organization with membership open to everyone. General meetings are open to the public and are free-of-charge; other activities may have a small admission fee to raise funds for continued preservation efforts. Contact the Historical Society through the Web site (www.mpmshistoricalsociety.org) or by telephone, (631) 476-5742.

www.arcadiapublishing.com

Discover books about the town where you grew up, the cities where your friends and families live, the town where your parents met, or even that retirement spot you've been dreaming about. Our Web site provides history lovers with exclusive deals, advanced notification about new titles, e-mail alerts of author events, and much more.

Arcadia Publishing, the leading local history publisher in the United States, is committed to making history accessible and meaningful through publishing books that celebrate and preserve the heritage of America's people and places. Consistent with our mission to preserve history on a local level, this book was printed in South Carolina on American-made paper and manufactured entirely in the United States.

This book carries the accredited Forest Stewardship Council (FSC) label and is printed on 100 percent FSC-certified paper. Products carrying the FSC label are independently certified to assure consumers that they come from forests that are managed to meet the social, economic, and ecological needs of present and future generations.

FSC
Mixed Sources
Product group from well-managed forests and other controlled sources

Cert no. SW-COC-001530
www.fsc.org
© 1996 Forest Stewardship Council

Find Your Place in History.